T0276950

designer's guide to color

4

BY IKUYOSHI SHIBUKAWA *AND* YUMI TAKAHASHI

CHRONICLE BOOKS
SAN FRANCISCO

THIS EDITION PUBLISHED IN 2007 BY CHRONICLE BOOKS LLC.

ENGLISH TEXT COPYRIGHT © 1990 BY CHRONICLE BOOKS.
COPYRIGHT © 1989 BY KAWADE SHOBO SHINSHA.
ALL RIGHTS RESERVED. NO PART OF THIS BOOK MAY BE REPRODUCED IN ANY
FORM WITHOUT WRITTEN PERMISSION FROM THE PUBLISHER.

HAISHOKU JITEN BY IKUYOSHI SHIBUKAWA AND YUMI TAKAHASHI WAS FIRST
PUBLISHED IN JAPAN BY KAWADE SHOBO SHINSHA PUBLISHERS.

ISBN-10: 0-8118-5709-3
ISBN-13: 978-0-8118-5709-3

THE LIBRARY OF CONGRESS HAS CATALOGED THE PREVIOUS EDITION
AS FOLLOWS:

SHIBUKAWA, IKUYOSHI.
DESIGNER'S GUIDE TO COLOR 4 / BY IKUYOSHI SHIBUKAWA
AND YUMI TAKAHASHI.
1. COLOR IN ART. 2. COLOR. 3. PSYCHOLOGICAL ASPECTS.
I. TAKAHASHI, YUMI. II. TITLE. III. TITLE: *DESIGNER'S GUIDE TO COLOR 4*.
ND 1488.S481990
701.'85-DC20 89-25473
ISBN: 0-87701-690-9
ISBN: 0-87701-681-X (PAPERBACK)

MANUFACTURED IN JAPAN.

DISTRIBUTED IN CANADA BY RAINCOAST BOOKS
9050 SHAUGHNESSY STREET
VANCOUVER, BRITISH COLUMBIA V6P 6E5

10 9 8 7 6 5 4 3 2 1

CHRONICLE BOOKS LLC
680 SECOND STREET
SAN FRANCISCO, CALIFORNIA 94107

WWW.CHRONICLEBOOKS.COM

Introduction

This easy-to-use *Designer's Guide to Color 4* is a color manual that consists of different categories of tones. The tones are first divided into four major categories, each of which is further divided, gradation by gradation, within the limitations of printability.

Group One: *Pale/Light/Bright* Three intensities of pastel tones

Group Two: *Dull* Tones low in saturation

Group Three: *Vivid/Deep* Tones high in saturation

Group Four: *Dark/Grayish* Saturated, dark tones and neutralized tones

At the beginning of each chapter, the basic colors are presented as individual chips, starting with yellow or the tone closest to yellow. Abundant color combinations can be made not only of tones in the same group but also of those in different groups. For printing purposes, each color combination comes with a description of the density. Density figures show percentages of yellow (Y), magenta (M), cyan (C), and black (BL) and can be used to designate colors for printing. The appendix illustrates the readability of white and black type on the various groups of tone. Gradation scales and charts of fluorescent colors are also provided.

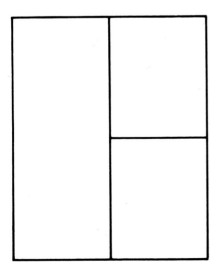

3-color combination

The basic 3-color format is proportioned 2:1:1. Because the three colors are next to each other, the relationship among them is easy to discern. The color in the large rectangle on the left can be seen as the background color, and the two colors in the smaller rectangles on the right can be thought of as patterns. Thus, it is possible to ascertain how a pairing of colors will appear on a particular ground.

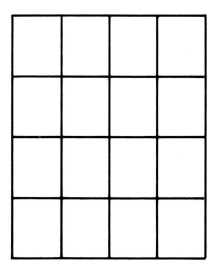

Mosaic
This format is most suitable for analyzing involved color schemes, such as those used for fabric design. Each overall mosaic is proportioned 2:1:1.

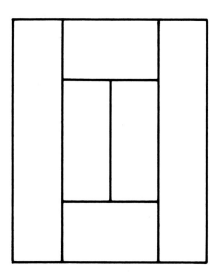

Black & White
Black, white, and gray are compatible with any color, and they are the inevitable connectors between colors. They also work to brighten or tighten a pattern. When either the right or left half of the pattern is masked out, the effect of the black or of the white is apparent.

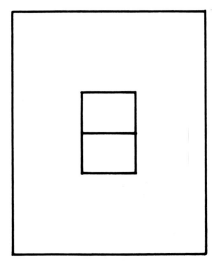

Point
The point effect is apparent when one color is surrounded by a background color. If you mask either the top or the bottom center rectangle, the impact of a single color point can be seen.

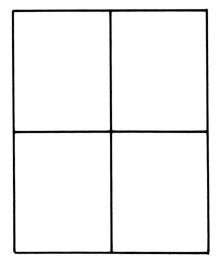

4-color combination
This equally divided 4-color combination is a kind of mosaic that gives a feeling not just for one color but for the patterns made by color combinations.

3

pale
light
bright

The range of colors from pale to bright includes pastel tones, which are effective for use of tone-on-tone and for gradations. If you want to control the intensity, add gray or dull colors at the point. Dull, dark, and grayish colors are harmonious with this range, but vivid colors lessen the strengths of the group. It is often necessary to use a technique like point when deep colors are involved. The tones in this group are created by mixing together two of the three primary colors used in printing.

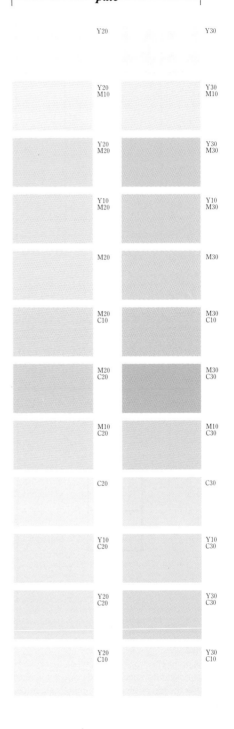

Y20 Y30

Y20/M10 Y30/M10

Y20/M20 Y30/M30

Y10/M20 Y10/M30

M20 M30

M20/C10 M30/C10

M20/C20 M30/C30

M10/C20 M10/C30

C20 C30

Y10/C20 Y10/C30

Y20/C20 Y30/C30

Y20/C10 Y30/C10

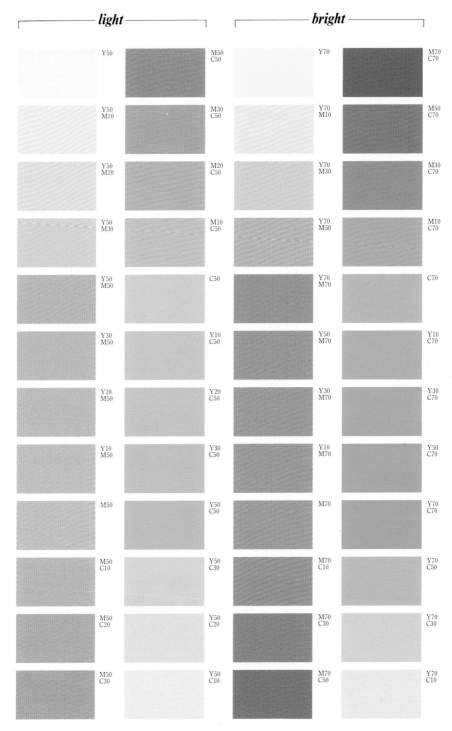

Y50	M50 C50
Y50 M10	M30 C50
Y50 M20	M20 C50
Y50 M30	M10 C50
Y50 M50	C50
Y30 M50	Y10 C50
Y20 M50	Y20 C50
Y10 M50	Y30 C50
M50	Y50 C50
M50 C10	Y50 C30
M50 C20	Y50 C20
M50 C30	Y50 C10

Y70	M70 C70
Y70 M10	M50 C70
Y70 M30	M30 C70
Y70 M50	M10 C70
Y70 M70	C70
Y50 M70	Y10 C70
Y30 M70	Y30 C70
Y10 M70	Y50 C70
M70	Y70 C70
M70 C10	Y70 C50
M70 C30	Y70 C30
M70 C50	Y70 C10

Pale 1

1

A Y10
B M10
C C10

6

A M10
B C10
C Y10 M10

11

A Y10 M10
B C10
C Y10 C10

2

A Y10
B M10
C Y10 C10

7

A M10
B C10
C Y10 C10

12

A Y10 M10
B C10
C M10 C10

3

A Y10
B M10
C M10 C10

8

A M10
B Y10 M10
C Y10 C10

13

A Y10 M10
B Y10 C10
C M10 C10

4

A Y10
B C10
C M10 C10

9

A M10
B Y10 M10
C M10 C10

14

A C10
B M10
C M10 C10

5

A Y10
B Y10 C10
C M10 C10

10

A M10
B Y10 C10
C M10 C10

15

A C10
B Y10 C10
C M10 C10

Pale, 4-color 1

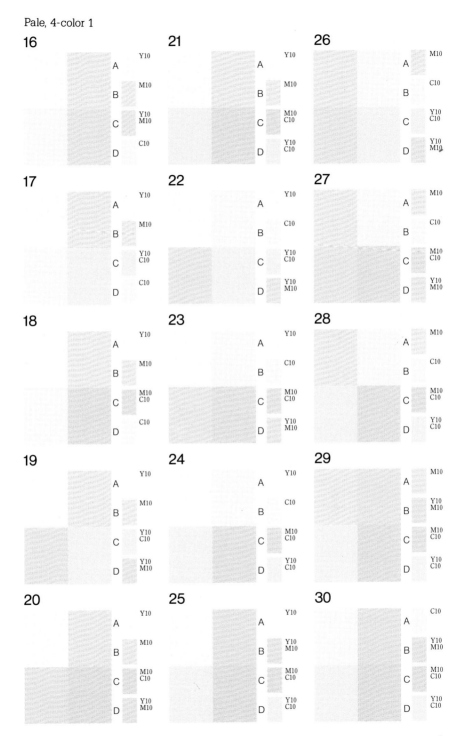

16

A Y10

B M10

C Y10 M10

D C10

17

A Y10

B M10

C Y10 C10

D C10

18

A Y10

B M10

C M10 C10

D C10

19

A Y10

B M10

C Y10 C10

D Y10 M10

20

A Y10

B M10

C M10 C10

D Y10 M10

21

A Y10

B M10

C M10 C10

D Y10 C10

22

A Y10

B C10

C Y10 C10

D Y10 M10

23

A Y10

B C10

C M10 C10

D Y10 M10

24

A Y10

B C10

C M10 C10

D Y10 C10

25

A Y10

B Y10 M10

C M10 C10

D Y10 C10

26

A M10

B C10

C Y10 C10

D Y10 M10

27

A M10

B C10

C M10 C10

D Y10 M10

28

A M10

B C10

C M10 C10

D Y10 C10

29

A M10

B Y10 M10

C M10 C10

D Y10 C10

30

A C10

B Y10 M10

C M10 C10

D Y10 C10

7

Pale 2

31

A Y20

B M20

C C20

36

A Y20

B C20

C M20 C20

32

A Y20

B M20

C Y10 C20

37

A Y20

B Y10 C20

C M20 C20

33

A Y20

B M20

C Y20 C20

38

A Y20 M10

B M20

C M20 C20

34

A Y20

B M20

C M20 C20

39

A Y20 M10

B Y10 M20

C Y10 C20

35

A Y20

B Y20 C20

C M20 C20

40

A Y20 M10

B Y20 C20

C M20 C20

8

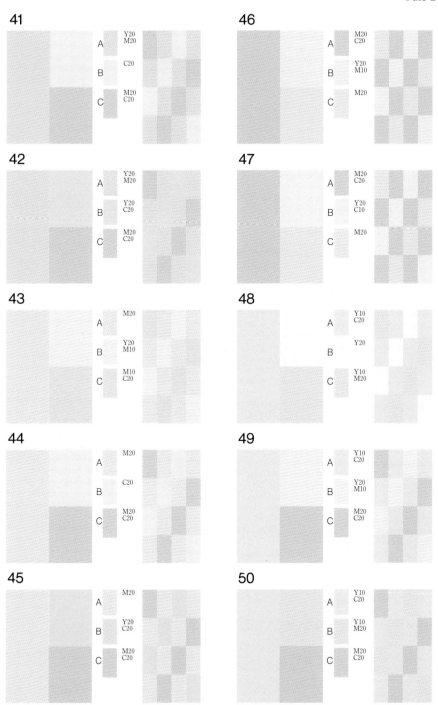

41

A Y20 M20

B C20

C M20 C20

46

A M20 C20

B Y20 M10

C M20

42

A Y20 M20

B Y20 C20

C M20 C20

47

A M20 C20

B Y20 C10

C M20

43

A M20

B Y20 M10

C M10 C20

48

A Y10 C20

B Y20

C Y10 M20

44

A M20

B C20

C M20 C20

49

A Y10 C20

B Y20 M10

C M20 C20

45

A M20

B Y20 C20

C M20 C20

50

A Y10 C20

B Y10 M20

C M20 C20

51

A	Y20
B	C20
C	M20
D	Y20 C20

56

A	Y20
B	M10 C20
C	Y20 M20
D	Y20 C20

61

A	Y20 M10
B	M10 C20
C	M20
D	Y20 C10

52

A	Y20
B	C20
C	M20
D	M20 C20

57

A	Y20
B	M20
C	M20 C20
D	Y20 M20

62

A	Y20 M10
B	C20
C	M20 C20
D	Y20 C20

53

A	Y20
B	C20
C	M20 C20
D	Y20 C20

58

A	Y20
B	Y10 C20
C	Y20 M20
D	M20 C20

63

A	Y20 M20
B	M10 C20
C	M20
D	Y20 C20

54

A	Y20
B	C20
C	Y20 M20
D	M20 C20

59

A	Y20 M10
B	Y20 C20
C	M20
D	C20

64

A	Y20 M20
B	C20
C	M20
D	M20 C20

55

A	Y20
B	Y20 C20
C	M20
D	M20 C20

60

A	Y20 M10
B	C20
C	M20
D	M20 C20

65

A	M20
B	C20
C	M20 C20
D	Y20 C20

Pale + Dull 1

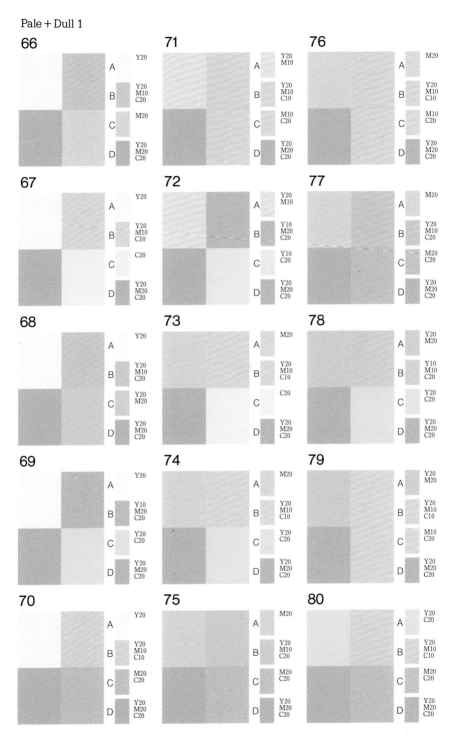

66

A — Y20
B — Y20 M10 C20
C — M20
D — Y20 M20 C20

71

A — Y20 M10
B — Y20 M10 C10
C — M10 C20
D — Y20 M20 C20

76

A — M20
B — Y20 M10 C10
C — M10 C20
D — Y20 M20 C20

67

A — Y20
B — Y20 M10 C10
C — C20
D — Y20 M20 C20

72

A — Y20 M10
B — Y10 M20 C20
C — Y10 C20
D — Y20 M20 C20

77

A — M20
B — Y20 M10 C20
C — M20 C20
D — Y20 M20 C20

68

A — Y20
B — Y20 M10 C20
C — Y20 M20
D — Y20 M20 C20

73

A — M20
B — Y20 M10 C10
C — C20
D — Y20 M20 C20

78

A — Y20 M20
B — Y10 M10 C20
C — Y20 C20
D — Y20 M20 C20

69

A — Y20
B — Y10 M20 C20
C — Y20 C20
D — Y20 M20 C20

74

A — M20
B — Y20 M10 C10
C — Y20 C20
D — Y20 M20 C20

79

A — Y20 M20
B — Y20 M10 C10
C — M10 C20
D — Y20 M20 C20

70

A — Y20
B — Y20 M10 C10
C — M20 C20
D — Y20 M20 C20

75

A — M20
B — Y20 M10 C20
C — M20 C20
D — Y20 M20 C20

80

A — Y20 C20
B — Y20 M10 C10
C — M20 C20
D — Y20 M20 C20

11

Pale 3

81

A Y30
B M30
C C30

82

A Y30
B M30
C Y30 C30

83

A Y30
B M30
C M30 C30

84

A Y30
B Y10 M30
C M10 C30

85

A Y30
B Y30 M30
C M10 C30

86

A Y30
B Y10 C30
C M30 C30

87

A Y30
B Y30 C30
C M30 C30

88

A Y30 M10
B M30
C M10 C30

89

A Y30 M10
B Y10 M30
C M30 C30

90

A Y30 M10
B Y10 M30
C Y30 C30

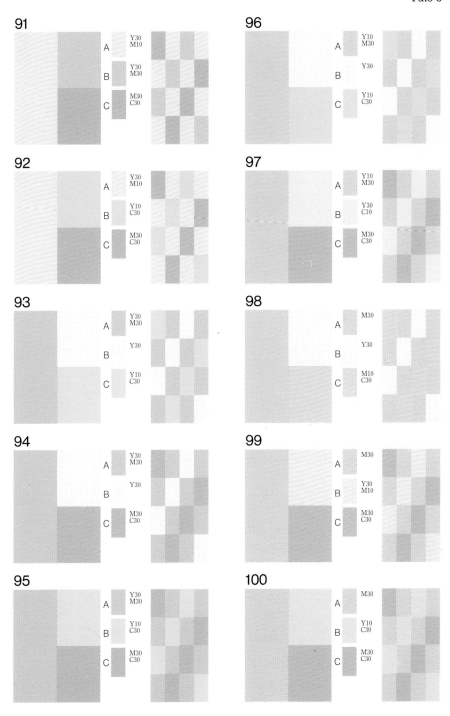

91

A Y30 M10
B Y30 M30
C M30 C30

96

A Y10 M30
B Y30
C Y10 C30

92

A Y30 M10
B Y10 C30
C M30 C30

97

A Y10 M30
B Y30 C10
C M30 C30

93

A Y30 M30
B Y30
C Y10 C30

98

A M30
B Y30
C M10 C30

94

A Y30 M30
B Y30
C M30 C30

99

A M30
B Y30 M10
C M30 C30

95

A Y30 M30
B Y10 C30
C M30 C30

100

A M30
B Y10 C30
C M30 C30

Pale 3

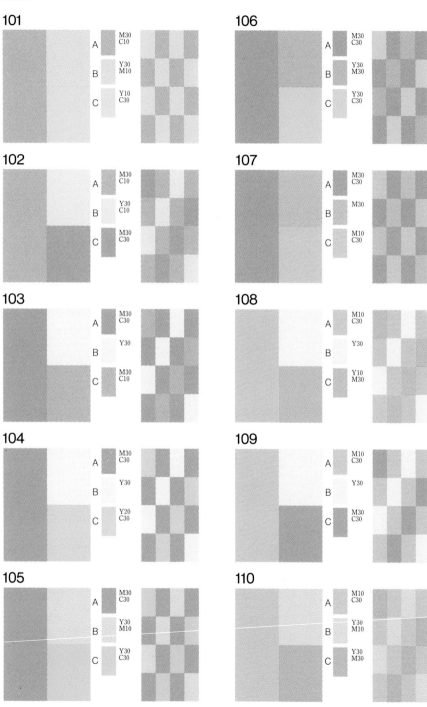

101

A M30 C10
B Y30 M10
C Y10 C30

106

A M30 C30
B Y30 M30
C Y30 C30

102

A M30 C10
B Y30 C10
C M30 C30

107

A M30 C30
B M30
C M10 C30

103

A M30 C30
B Y30
C M30 C10

108

A M10 C30
B Y30
C Y10 M30

104

A M30 C30
B Y30
C Y20 C30

109

A M10 C30
B Y30
C M30 C30

105

A M30 C30
B Y30 M10
C Y30 C30

110

A M10 C30
B Y30 M10
C Y30 M30

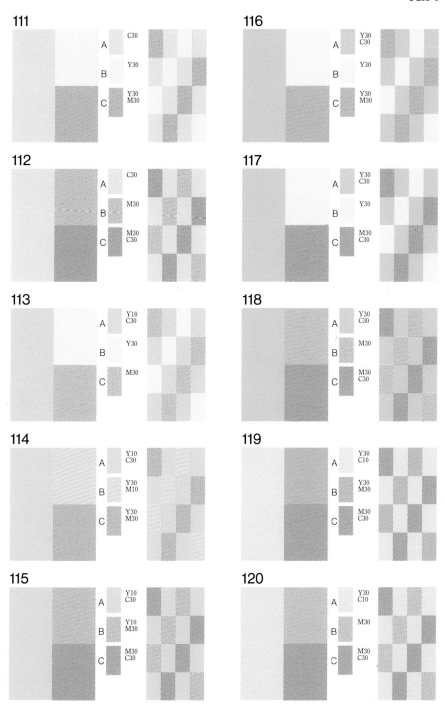

111
A — C30
B — Y30
C — Y30 M30

116
A — Y30 C30
B — Y30
C — Y30 M30

112
A — C30
B — M30
C — M30 C30

117
A — Y30 C30
B — Y30
C — M30 C30

113
A — Y10 C30
B — Y30
C — M30

118
A — Y30 C30
B — M30
C — M30 C30

114
A — Y10 C30
B — Y30 M10
C — Y30 M30

119
A — Y30 C10
B — Y30 M30
C — M30 C30

115
A — Y10 C30
B — Y10 M30
C — M30 C30

120
A — Y30 C10
B — M30
C — M30 C30

Pale, 4-color 2

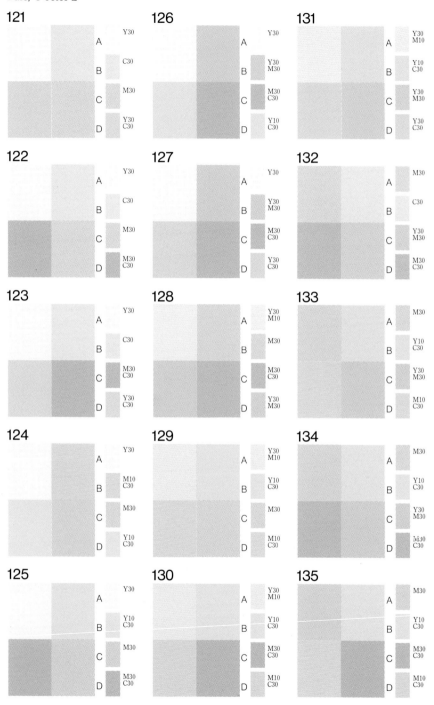

121
A Y30
B C30
C M30
D Y30 C30

126
A Y30
B Y30 M30
C M30 C30
D Y10 C30

131
A Y30 M10
B Y10 C30
C Y30 M30
D Y30 C30

122
A Y30
B C30
C M30
D M30 C30

127
A Y30
B Y30 M30
C M30 C30
D Y30 C30

132
A M30
B C30
C Y30 M30
D M30 C30

123
A Y30
B C30
C M30 C30
D Y30 C30

128
A Y30 M10
B M30
C M30 C30
D Y30 M30

133
A M30
B Y10 C30
C Y30 M30
D M10 C30

124
A Y30
B M10 C30
C M30
D Y10 C30

129
A Y30 M10
B Y10 C30
C M30
D M10 C30

134
A M30
B Y10 C30
C Y30 M30
D M30 C30

125
A Y30
B Y10 C30
C M30
D M30 C30

130
A Y30 M10
B Y10 C30
C M30 C30
D M10 C30

135
A M30
B Y10 C30
C M30 C30
D M10 C30

16

Pale + Dull 2

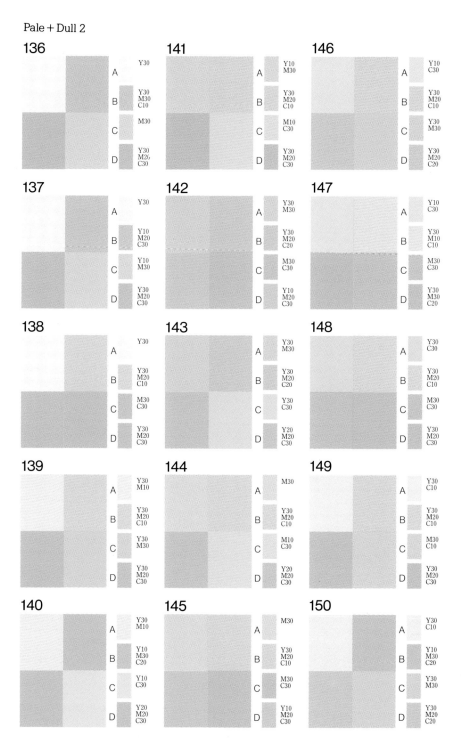

136
A Y30
B Y30 M30 C10
C M30
D Y30 M20 C30

141
A Y10 M30
B Y30 M20 C10
C M10 C30
D Y30 M20 C30

146
A Y10 C30
B Y30 M20 C10
C Y30 M30
D Y30 M20 C20

137
A Y30
B Y10 M20 C30
C Y10 M30
D Y30 M20 C30

142
A Y30 M30
B Y30 M20 C20
C M30 C30
D Y10 M20 C30

147
A Y10 C30
B Y30 M10 C10
C M30 C30
D Y30 M30 C20

138
A Y30
B Y30 M20 C10
C M30 C30
D Y30 M20 C30

143
A Y30 M30
B Y30 M20 C20
C Y30 C30
D Y20 M20 C30

148
A Y30 C30
B Y30 M20 C10
C M30 C30
D Y30 M20 C30

139
A Y30 M10
B Y30 M20 C10
C Y30 M30
D Y30 M20 C30

144
A M30
B Y30 M20 C10
C M10 C30
D Y20 M20 C30

149
A Y30 C10
B Y30 M20 C10
C M30 C10
D Y30 M20 C30

140
A Y30 M10
B Y10 M30 C20
C Y10 C30
D Y20 M20 C30

145
A M30
B Y30 M20 C10
C M30 C30
D Y10 M20 C30

150
A Y30 C10
B Y10 M30 C20
C Y30 M30
D Y30 M20 C20

Pale, Gradation

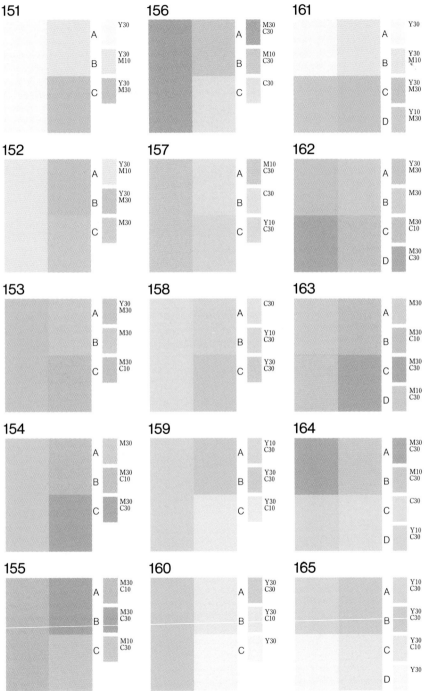

151

A — Y30
B — Y30 M10
C — Y30 M30

152

A — Y30 M10
B — Y30 M30
C — M30

153

A — Y30 M30
B — M30
C — M30 C10

154

A — M30
B — M30 C10
C — M30 C30

155

A — M30 C10
B — M30 C30
C — M10 C30

156

A — M30 C30
B — M10 C30
C — C30

157

A — M10 C30
B — C30
C — Y10 C30

158

A — C30
B — Y10 C30
C — Y30 C30

159

A — Y10 C30
B — Y30 C30
C — Y30 C10

160

A — Y30 C30
B — Y30 C10
C — Y30

161

A — Y30
B — Y30 M10
C — Y30 M30
D — Y10 M30

162

A — Y30 M30
B — M30
C — M30 C10
D — M30 C30

163

A — M30
B — M30 C10
C — M30 C30
D — M10 C30

164

A — M30 C30
B — M10 C30
C — C30
D — Y10 C30

165

A — Y10 C30
B — Y30 C30
C — Y30 C10
D — Y30

Light, Gradation

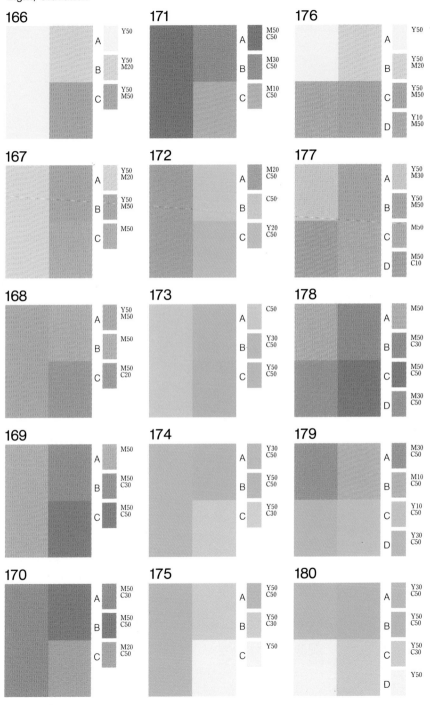

166
- A — Y50
- B — Y50 M20
- C — Y50 M50

171
- A — M50 C50
- B — M30 C50
- C — M10 C50

176
- A — Y50
- B — Y50 M20
- C — Y50 M50
- D — Y10 M50

167
- A — Y50 M20
- B — Y50 M50
- C — M50

172
- A — M20 C50
- B — C50
- C — Y20 C50

177
- A — Y50 M30
- B — Y50 M50
- C — M50
- D — M50 C10

168
- A — Y50 M50
- B — M50
- C — M50 C20

173
- A — C50
- B — Y30 C50
- C — Y50 C50

178
- A — M50
- B — M50 C30
- C — M50 C50
- D — M30 C50

169
- A — M50
- B — M50 C30
- C — M50 C50

174
- A — Y30 C50
- B — Y50 C50
- C — Y50 C30

179
- A — M30 C50
- B — M10 C50
- C — Y10 C50
- D — Y30 C50

170
- A — M50 C30
- B — M50 C50
- C — M20 C50

175
- A — Y50 C50
- B — Y50 C30
- C — Y50

180
- A — Y30 C50
- B — Y50 C50
- C — Y50 C30
- D — Y50

181

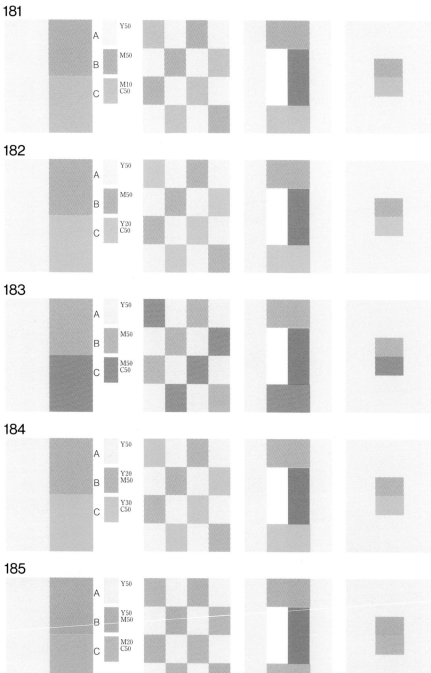

A Y50

B M50

C M10 C50

182

A Y50

B M50

C Y20 C50

183

A Y50

B M50

C M50 C50

184

A Y50

B Y20 M50

C Y30 C50

185

A Y50

B Y50 M50

C M20 C50

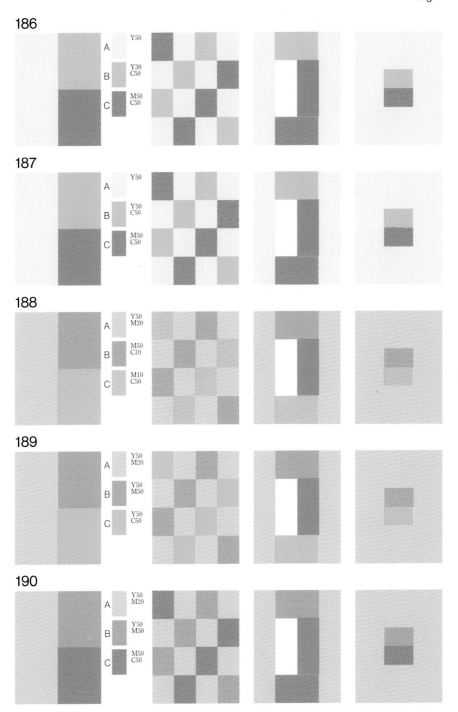

186

A Y50
B Y30 C50
C M50 C50

187

A Y50
B Y50 C50
C M50 C50

188

A Y50 M20
B M50 C10
C M10 C50

189

A Y50 M20
B Y50 M50
C Y50 C50

190

A Y50 M20
B Y50 M50
C M50 C50

191

192

193

194

195

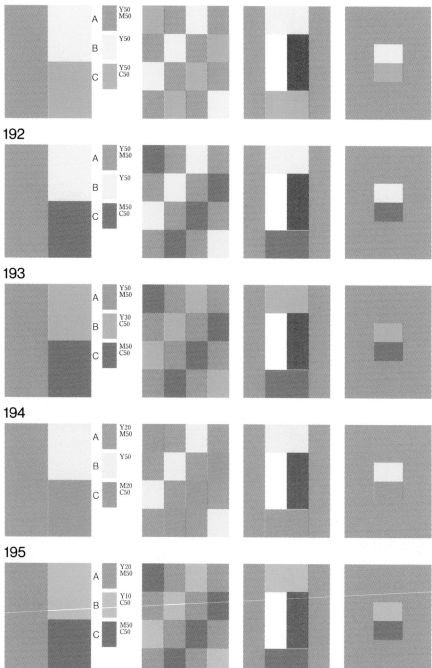

A Y50 M50
B Y50
C Y50 C50

A Y50 M50
B Y50
C M50 C50

A Y50 M50
B Y30 C50
C M50 C50

A Y20 M50
B Y50
C M20 C50

A Y20 M50
B Y10 C50
C M50 C50

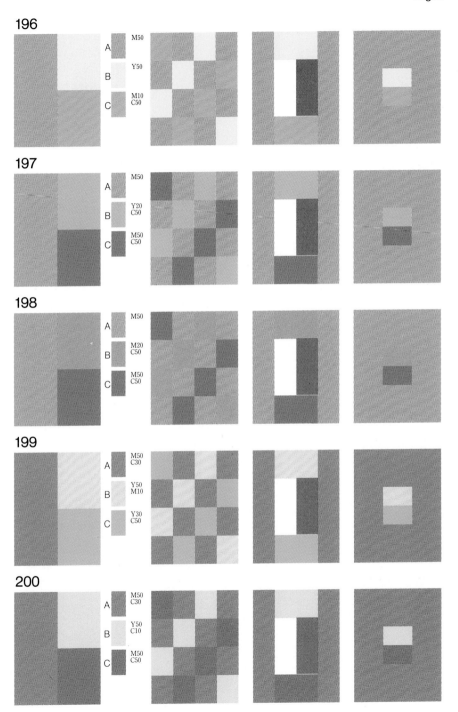

196
A M50
B Y50
C M10 C50

197
A M50
B Y20 C50
C M50 C50

198
A M50
B M20 C50
C M50 C50

199
A M50 C30
B Y50 M10
C Y30 C50

200
A M50 C30
B Y50 C10
C M50 C50

Light

201

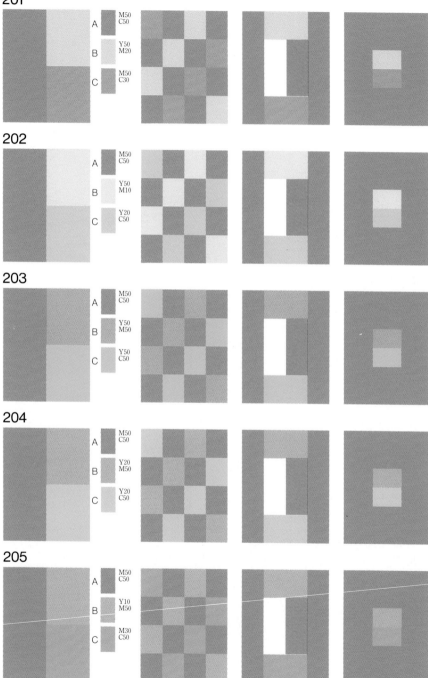

A	M50 C50
B	Y50 M20
C	M50 C30

202

A	M50 C50
B	Y50 M10
C	Y20 C50

203

A	M50 C50
B	Y50 M50
C	Y50 C50

204

A	M50 C50
B	Y20 M50
C	Y20 C50

205

A	M50 C50
B	Y10 M50
C	M30 C50

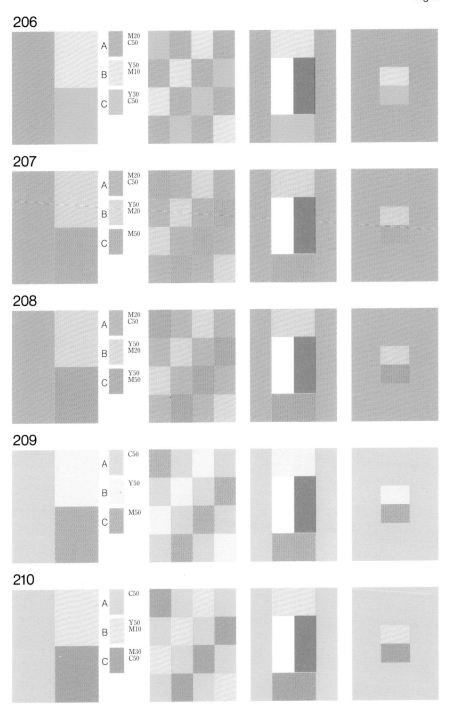

206

A — M20 C50
B — Y50 M10
C — Y30 C50

207

A — M20 C50
B — Y50 M20
C — M50

208

A — M20 C50
B — Y50 M20
C — Y50 M50

209

A — C50
B — Y50
C — M50

210

A — C50
B — Y50 M10
C — M30 C50

211

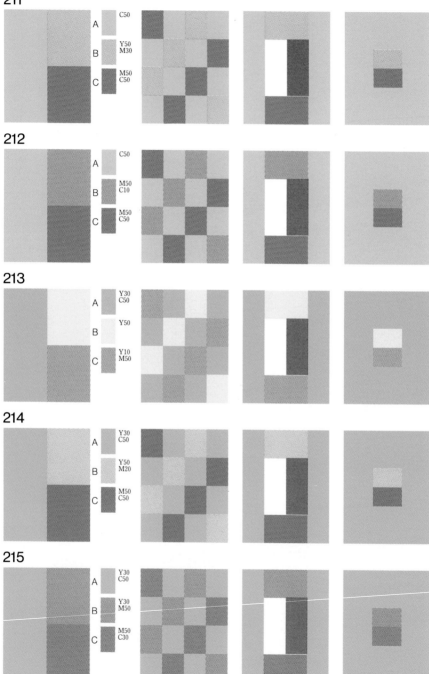

A C50

B Y50 M30

C M50 C50

212

A C50

B M50 C10

C M50 C50

213

A Y30 C50

B Y50

C Y10 M50

214

A Y30 C50

B Y50 M20

C M50 C50

215

A Y30 C50

B Y30 M50

C M50 C30

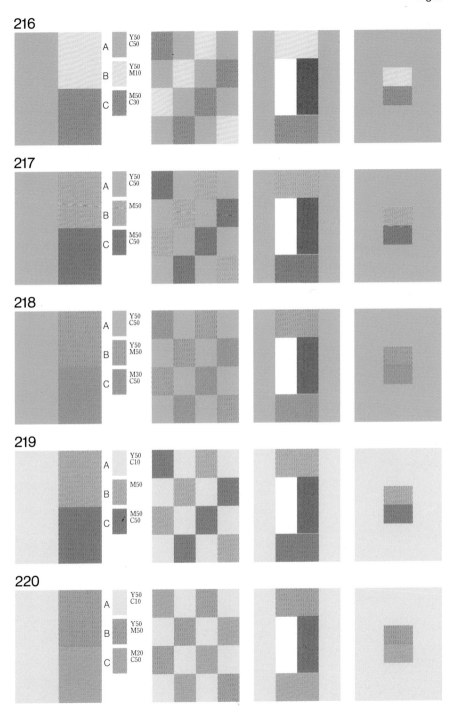

216

A Y50 C50
B Y50 M10
C M50 C30

217

A Y50 C50
B M50
C M50 C50

218

A Y50 C50
B Y50 M50
C M30 C50

219

A Y50 C10
B M50
C M50 C50

220

A Y50 C10
B Y50 M50
C M20 C50

Light, 4-color

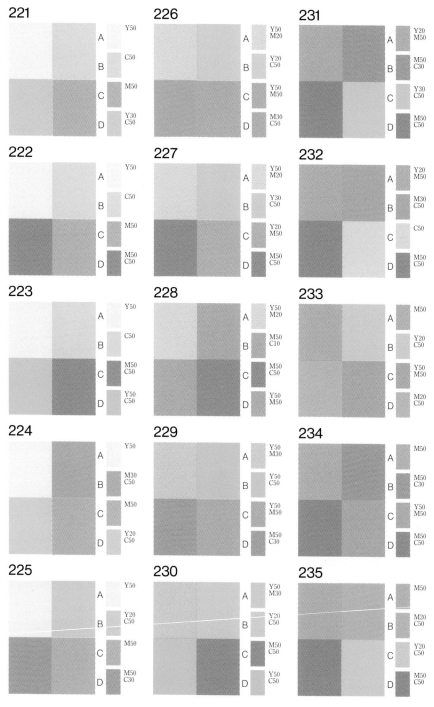

221
A Y50
B C50
C M50
D Y30 C50

226
A Y50 M20
B Y20 C50
C Y50 M50
D M30 C50

231
A Y20 M50
B M50 C30
C Y30 C50
D M50 C50

222
A Y50
B C50
C M50
D M50 C50

227
A Y50 M20
B Y30 C50
C Y20 M50
D M50 C50

232
A Y20 M50
B M30 C50
C C50
D M50 C50

223
A Y50
B C50
C M50 C50
D Y50 C50

228
A Y50 M20
B M50 C10
C M50 C50
D Y50 M50

233
A M50
B Y20 C50
C Y50 M50
D M20 C50

224
A Y50
B M30 C50
C M50
D Y20 C50

229
A Y50 M30
B Y50 C50
C Y50 M50
D M50 C30

234
A M50
B M50 C30
C Y50 M50
D M50 C50

225
A Y50
B Y20 C50
C M50
D M50 C30

230
A Y50 M30
B Y20 C50
C M50 C50
D Y50 C50

235
A M50
B M20 C50
C Y20 C50
D M50 C50

236

A	Y50
B	Y40 M30 C40
C	M50
D	Y30 M40 C50

241

A	Y50 M50
B	Y40 M20 C20
C	Y50 C50
D	Y50 M40 C50

246

A	M30 C50
B	Y40 M40 C30
C	M50 C50
D	Y30 M40 C40

237

A	Y50
B	Y40 M30 C40
C	Y50 M50
D	Y30 M40 C50

242

A	Y50 M50
B	Y30 M30 C20
C	M50 C50
D	Y50 M30 C40

247

A	M30 C50
B	Y30 M30 C30
C	Y20 M50
D	Y30 M50 C50

238

A	Y50
B	Y50 M40 C30
C	Y20 C50
D	Y30 M40 C50

243

A	Y20 M50
B	Y40 M30 C40
C	M40 C50
D	Y30 M30 C50

248

A	C50
B	Y30 M20 C20
C	M50 C10
D	Y30 M40 C50

239

A	Y50 M20
B	Y50 M30 C30
C	Y30 C50
D	Y40 M40 C40

244

A	Y20 M50
B	Y40 M20 C20
C	Y30 C50
D	Y30 M30 C50

249

A	Y30 C50
B	Y50 M40 C30
C	M40 C50
D	Y40 M50 C50

240

A	Y50 M20
B	Y40 M40 C40
C	M50 C50
D	Y30 M30 C50

245

A	M50
B	Y30 M20 C20
C	M50 C50
D	Y30 M40 C40

250

A	Y50 C10
B	Y30 M20 C20
C	M50 C50
D	Y50 M40 C20

Bright

251

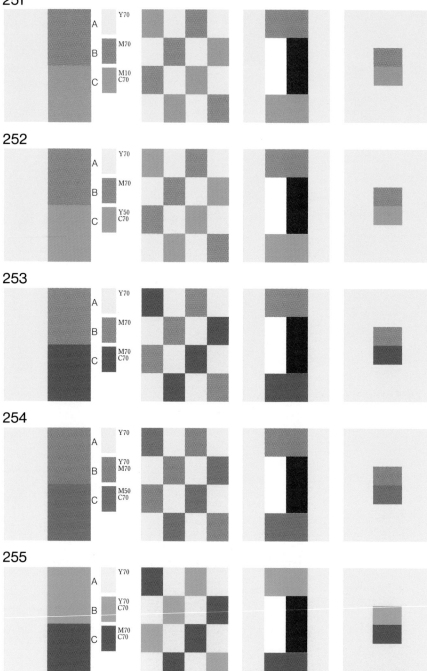

A	Y70
B	M70
C	M10 C70

252

A	Y70
B	M70
C	Y50 C70

253

A	Y70
B	M70
C	M70 C70

254

A	Y70
B	Y70 M70
C	M50 C70

255

A	Y70
B	Y70 C70
C	M70 C70

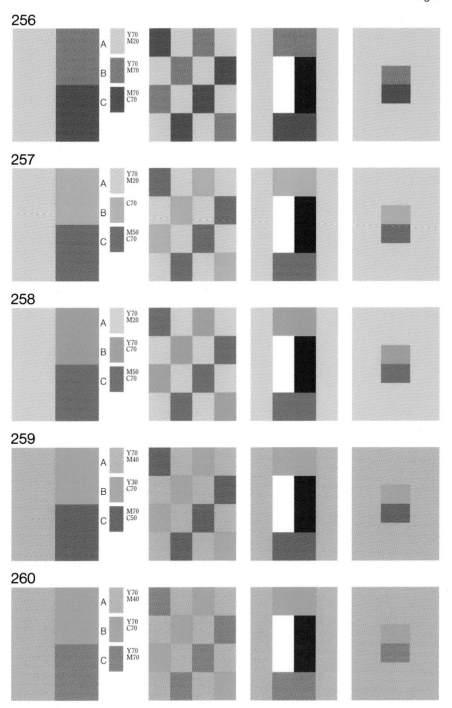

256

A Y70 M20
B Y70 M70
C M70 C70

257

A Y70 M20
B C70
C M50 C70

258

A Y70 M20
B Y70 C70
C M50 C70

259

A Y70 M40
B Y30 C70
C M70 C50

260

A Y70 M40
B Y70 C70
C Y70 M70

Bright

261

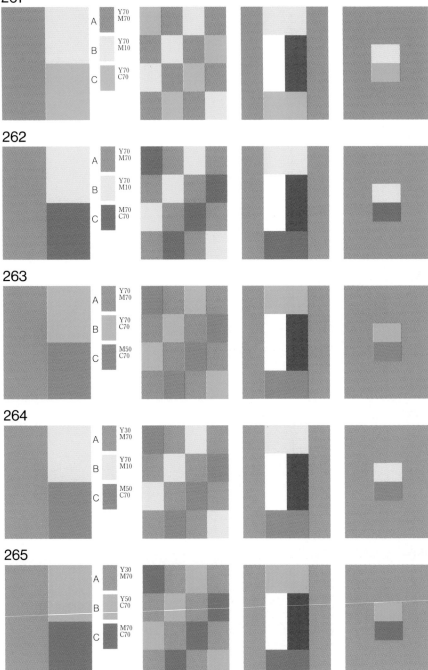

261
A · Y70 M70
B · Y70 M10
C · Y70 C70

262

A · Y70 M70
B · Y70 M10
C · M70 C70

263

A · Y70 M70
B · Y70 C70
C · M50 C70

264

A · Y30 M70
B · Y70 M10
C · M50 C70

265

A · Y30 M70
B · Y50 C70
C · M70 C70

266

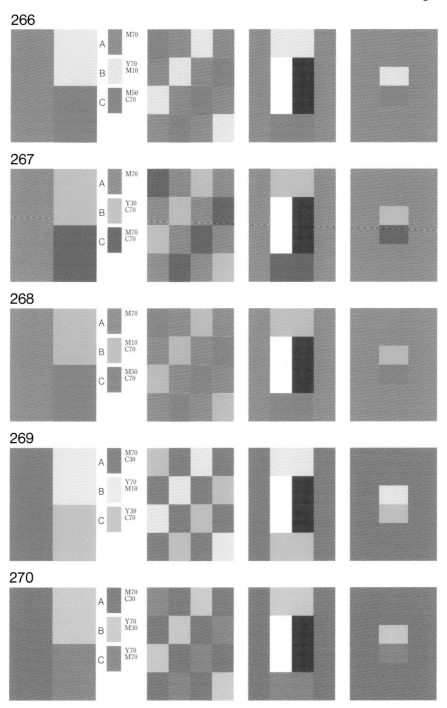

A	M70
B	Y70 M10
C	M50 C70

267

A	M70
B	Y30 C70
C	M70 C70

268

A	M70
B	M10 C70
C	M50 C70

269

A	M70 C30
B	Y70 M10
C	Y30 C70

270

A	M70 C30
B	Y70 M30
C	Y70 M70

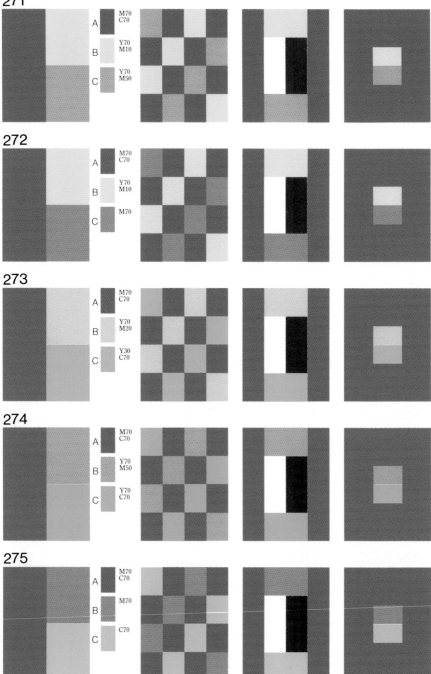

271

A M70 C70
B Y70 M10
C Y70 M50

272

A M70 C70
B Y70 M10
C M70

273

A M70 C70
B Y70 M20
C Y30 C70

274

A M70 C70
B Y70 M50
C Y70 C70

275

A M70 C70
B M70
C C70

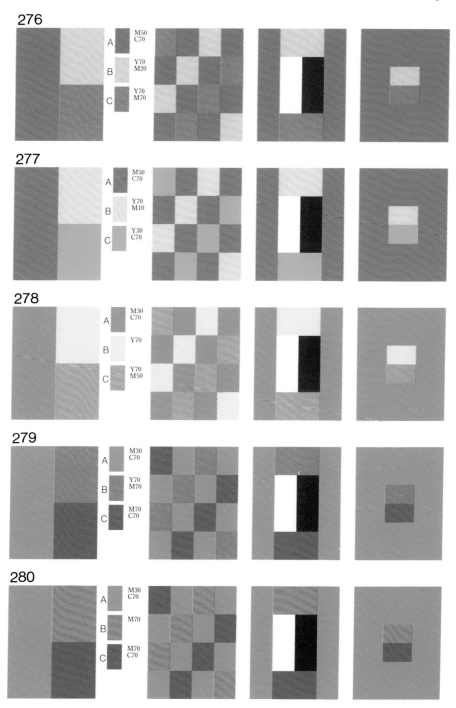

276

A M50 C70
B Y70 M20
C Y70 M70

277

A M50 C70
B Y70 M10
C Y30 C70

278

A M30 C70
B Y70
C Y70 M50

279

A M30 C70
B Y70 M70
C M70 C70

280

A M30 C70
B M70
C M70 C70

Bright

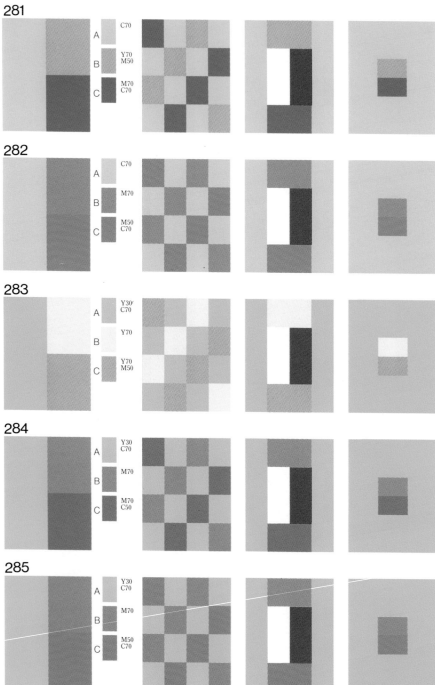

281

A C70

B Y70 M50

C M70 C70

282

A C70

B M70

C M50 C70

283

A Y30 C70

B Y70

C Y70 M50

284

A Y30 C70

B M70

C M70 C50

285

A Y30 C70

B M70

C M50 C70

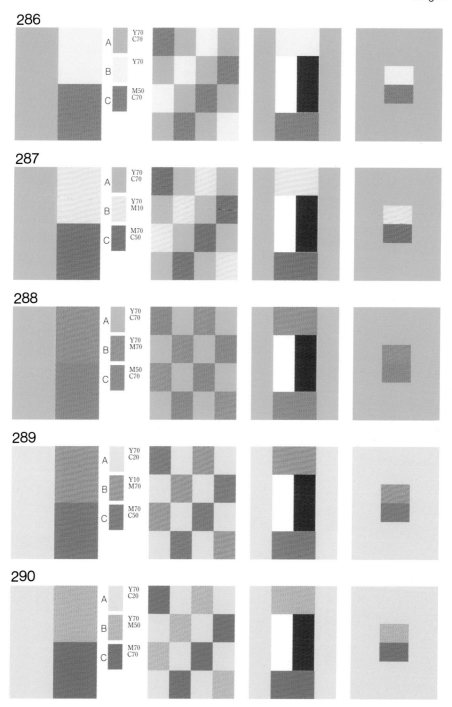

286

A — Y70 C70
B — Y70
C — M50 C70

287

A — Y70 C70
B — Y70 M10
C — M70 C50

288

A — Y70 C70
B — Y70 M70
C — M50 C70

289

A — Y70 C20
B — Y10 M70
C — M70 C50

290

A — Y70 C20
B — Y70 M50
C — M70 C70

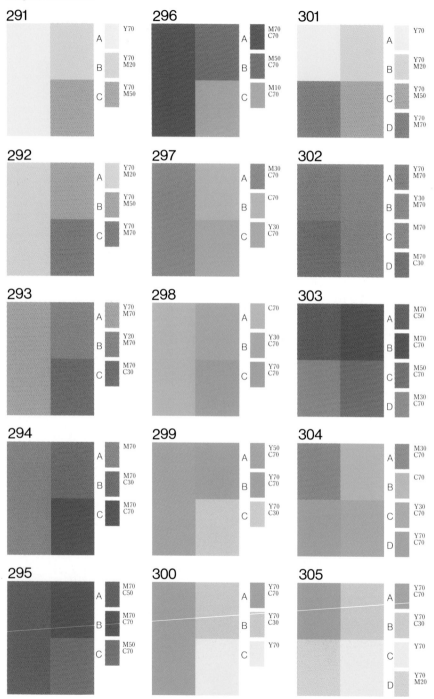

291
A — Y70
B — Y70 M20
C — Y70 M50

296
A — M70 C70
B — M50 C70
C — M10 C70

301
A — Y70
B — Y70 M20
C — Y70 M50
D — Y70 M70

292
A — Y70 M20
B — Y70 M50
C — Y70 M70

297
A — M30 C70
B — C70
C — Y30 C70

302
A — Y70 M70
B — Y30 M70
C — M70
D — M70 C30

293
A — Y70 M70
B — Y20 M70
C — M70 C30

298
A — C70
B — Y30 C70
C — Y70 C70

303
A — M70 C50
B — M70 C70
C — M50 C70
D — M30 C70

294
A — M70
B — M70 C30
C — M70 C70

299
A — Y50 C70
B — Y70 C70
C — Y70 C30

304
A — M30 C70
B — C70
C — Y30 C70
D — Y70 C70

295
A — M70 C50
B — M70 C70
C — M50 C70

300
A — Y70 C70
B — Y70 C30
C — Y70

305
A — Y70 C70
B — Y70 C30
C — Y70
D — Y70 M20

Bright, 4-color

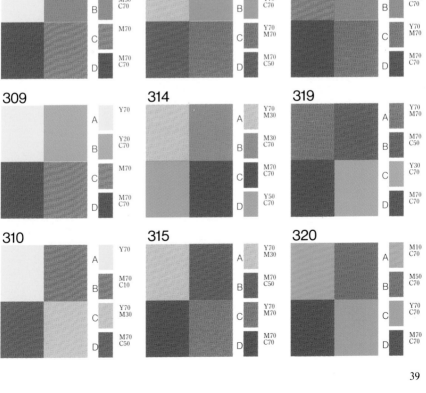

306
- A: Y70
- B: C70
- C: M50 C70
- D: Y70 C70

307
- A: Y70
- B: M30 C70
- C: M70
- D: Y30 C70

308
- A: Y70
- B: M30 C70
- C: M70
- D: M70 C70

309
- A: Y70
- B: Y20 C70
- C: M70
- D: M70 C70

310
- A: Y70
- B: M70 C10
- C: Y70 M30
- D: M70 C50

311
- A: Y70 M10
- B: M10 C70
- C: Y70 M70
- D: M50 C70

312
- A: Y70 M10
- B: M70 C30
- C: Y70 M30
- D: M70 C70

313
- A: Y70 M30
- B: Y70 C70
- C: Y70 M70
- D: M70 C50

314
- A: Y70 M30
- B: M30 C70
- C: M70 C70
- D: Y50 C70

315
- A: Y70 M30
- B: M70 C50
- C: Y70 M70
- D: M70 C70

316
- A: M70
- B: Y30 C70
- C: Y70 M70
- D: M30 C70

317
- A: M70
- B: Y20 C70
- C: M70 C50
- D: M70 C70

318
- A: M70
- B: M30 C70
- C: Y70 M70
- D: M70 C70

319
- A: Y70 M70
- B: M70 C50
- C: Y30 C70
- D: M70 C70

320
- A: M10 C70
- B: M50 C70
- C: Y70 C70
- D: M70 C70

dull

These tones low in saturation have a wide range and are divided into four separate categories according to brightness. The combinations in each category are easy to make because the three primary printing colors are mixed together. These tones complement other colors, especially deep, dark, grayish tones. Although vivid colors should be used carefully with this group, dull colors can control the strength of vivid colors. Use of black can tighten an overall pattern of dull colors and also emphasize their beauty.

dull ①②

①
Y20 M10 C10	Y10 M30 C30
Y20 M20 C10	Y10 M20 C30
Y10 M20 C10	Y10 M10 C30
Y10 M20 C20	Y20 M10 C30
Y10 M10 C20	Y30 M10 C30
Y20 M10 C20	Y30 M10 C20

②
Y30 M10 C10	Y30 M20 C20
Y30 M20 C10	Y30 M30 C20
Y30 M30 C10	Y20 M30 C20
Y20 M30 C10	Y20 M30 C30
Y10 M30 C10	Y20 M20 C30
Y10 M30 C20	Y30 M20 C30

dull ③ dull ④

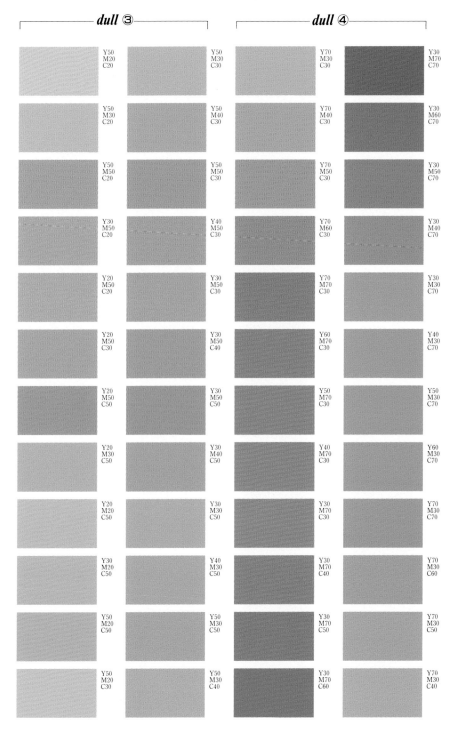

Y50 M20 C20	Y50 M30 C30	Y70 M30 C30	Y30 M70 C70
Y50 M30 C20	Y50 M40 C30	Y70 M40 C30	Y30 M60 C70
Y50 M50 C20	Y50 M50 C30	Y70 M50 C30	Y30 M50 C70
Y30 M50 C20	Y40 M50 C30	Y70 M60 C30	Y30 M40 C70
Y20 M50 C20	Y30 M50 C30	Y70 M70 C30	Y30 M30 C70
Y20 M50 C30	Y30 M50 C40	Y60 M70 C30	Y40 M30 C70
Y20 M50 C50	Y30 M50 C50	Y50 M70 C30	Y50 M30 C70
Y20 M30 C50	Y30 M40 C50	Y40 M70 C30	Y60 M30 C70
Y20 M20 C50	Y30 M30 C50	Y30 M70 C30	Y70 M30 C70
Y30 M20 C50	Y40 M30 C50	Y30 M70 C40	Y70 M30 C60
Y50 M20 C50	Y50 M30 C50	Y30 M70 C50	Y70 M30 C50
Y50 M20 C30	Y50 M30 C40	Y30 M70 C60	Y70 M30 C40

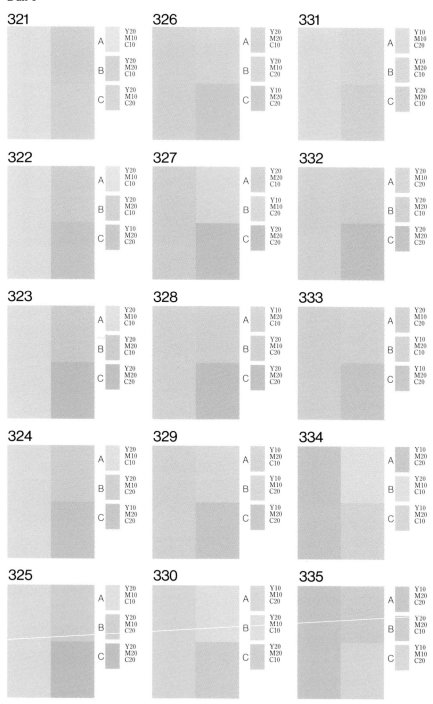

321

A Y20 M10 C10

B Y20 M20 C10

C Y20 M10 C20

326

A Y20 M20 C10

B Y20 M10 C20

C Y10 M20 C20

331

A Y10 M10 C20

B Y10 M20 C10

C Y20 M20 C10

322

A Y20 M10 C10

B Y20 M20 C10

C Y10 M20 C20

327

A Y20 M20 C10

B Y10 M10 C20

C Y20 M20 C20

332

A Y20 M10 C20

B Y20 M20 C10

C Y20 M20 C20

323

A Y20 M20 C10

B Y20 M20 C10

C Y20 M20 C20

328

A Y10 M20 C10

B Y20 M10 C20

C Y20 M20 C20

333

A Y20 M10 C20

B Y10 M20 C10

C Y10 M20 C20

324

A Y20 M10 C10

B Y20 M10 C20

C Y10 M20 C20

329

A Y10 M20 C10

B Y10 M10 C20

C Y10 M20 C20

334

A Y10 M20 C20

B Y20 M10 C10

C Y10 M20 C10

325

A Y20 M10 C10

B Y20 M10 C20

C Y20 M20 C20

330

A Y10 M10 C20

B Y20 M10 C10

C Y20 M20 C10

335

A Y10 M20 C20

B Y20 M20 C10

C Y10 M10 C20

Dull 2

336

A Y30 M10 C10
B Y30 M20 C20
C Y20 M30 C30

341

A Y30 M20 C10
B Y10 M30 C10
C Y10 M20 C30

346

A Y10 M30 C30
B Y30 M10 C10
C Y30 M30 C10

337

A Y30 M10 C10
B Y20 M30 C10
C Y10 M30 C30

342

A Y30 M20 C10
B Y20 M30 C20
C Y20 M20 C30

347

A Y10 M20 C30
B Y30 M10 C10
C Y20 M30 C10

338

A Y30 M10 C10
B Y10 M30 C10
C Y20 M20 C30

343

A Y30 M20 C10
B Y10 M10 C30
C Y10 M30 C30

348

A Y10 M20 C30
B Y20 M10 C30
C Y20 M30 C30

339

A Y30 M10 C10
B Y20 M10 C30
C Y30 M30 C20

344

A Y10 M30 C10
B Y20 M10 C30
C Y10 M30 C30

349

A Y20 M10 C30
B Y10 M30 C30
C Y20 M20 C30

340

A Y30 M10 C10
B Y30 M10 C30
C Y20 M30 C20

345

A Y10 M30 C10
B Y10 M10 C30
C Y20 M20 C30

350

A Y30 M10 C30
B Y30 M20 C20
C Y30 M30 C20

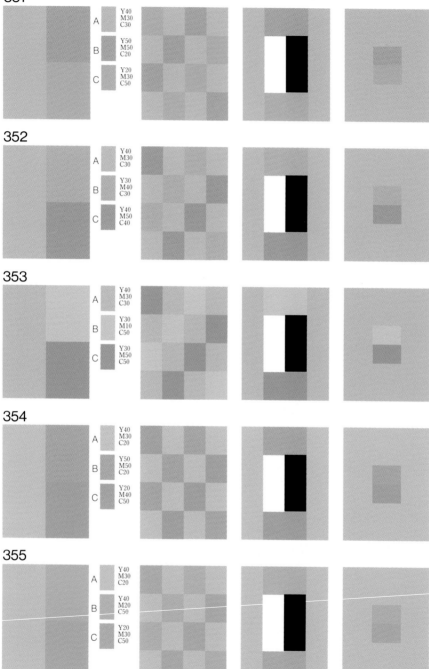

351

A
Y40
M30
C30

B
Y50
M50
C20

C
Y20
M30
C50

352

A
Y40
M30
C30

B
Y30
M40
C30

C
Y40
M50
C40

353

A
Y40
M30
C30

B
Y30
M10
C50

C
Y30
M50
C50

354

A
Y40
M30
C20

B
Y50
M50
C20

C
Y20
M40
C50

355

A
Y40
M30
C20

B
Y40
M20
C50

C
Y20
M30
C50

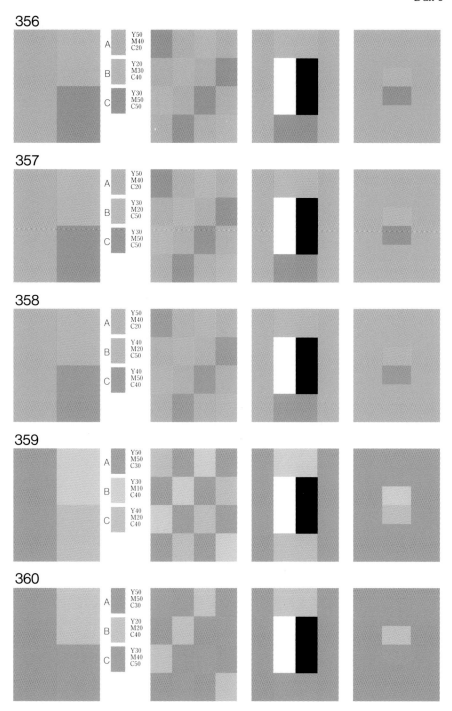

356

A Y50 M40 C20
B Y20 M30 C40
C Y30 M50 C50

357

A Y50 M40 C20
B Y30 M20 C50
C Y30 M50 C50

358

A Y50 M40 C20
B Y40 M20 C50
C Y40 M50 C40

359

A Y50 M50 C30
B Y30 M10 C40
C Y40 M20 C40

360

A Y50 M50 C30
B Y20 M20 C40
C Y30 M40 C50

361

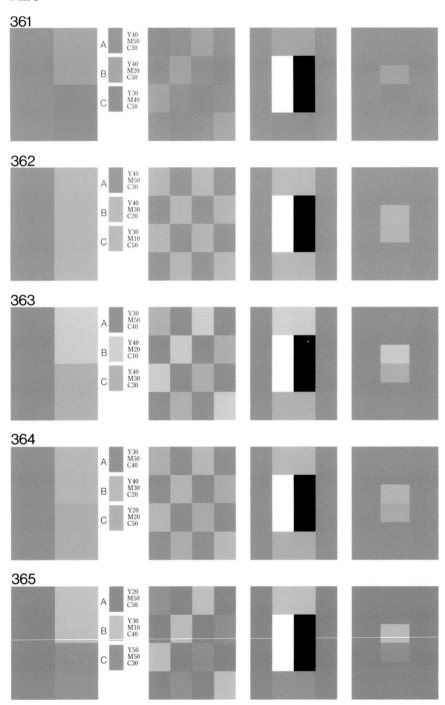

A — Y40 M50 C30
B — Y40 M20 C50
C — Y30 M40 C50

362

A — Y40 M50 C30
B — Y40 M30 C20
C — Y30 M10 C50

363

A — Y30 M50 C40
B — Y40 M20 C10
C — Y40 M30 C30

364

A — Y30 M50 C40
B — Y40 M30 C20
C — Y20 M20 C50

365

A — Y20 M50 C50
B — Y30 M10 C40
C — Y50 M50 C30

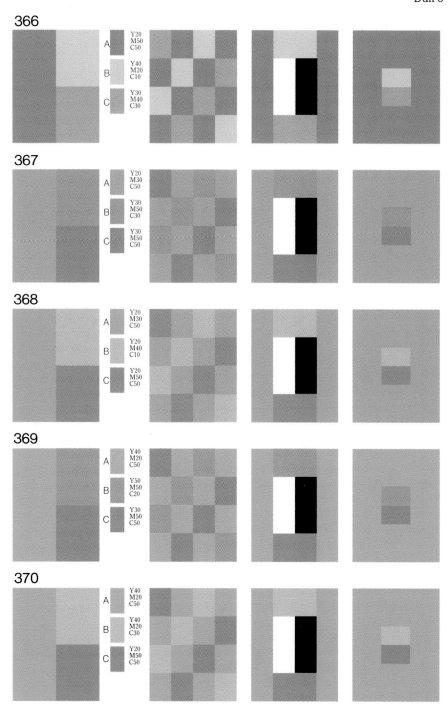

366

A
Y20
M50
C50

B
Y40
M20
C10

C
Y30
M40
C30

367

A
Y20
M30
C50

B
Y30
M50
C30

C
Y30
M50
C50

368

A
Y20
M30
C50

B
Y20
M40
C10

C
Y20
M50
C50

369

A
Y40
M20
C50

B
Y50
M50
C20

C
Y30
M50
C50

370

A
Y40
M20
C50

B
Y40
M20
C30

C
Y20
M50
C50

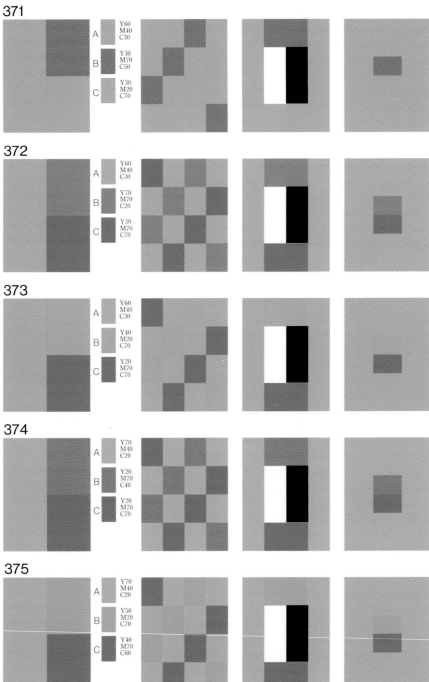

371

A Y60 M40 C30
B Y30 M70 C50
C Y30 M20 C70

372

A Y60 M40 C30
B Y70 M70 C20
C Y30 M70 C70

373

A Y60 M40 C30
B Y40 M20 C70
C Y20 M70 C70

374

A Y70 M40 C20
B Y20 M70 C40
C Y20 M70 C70

375

A Y70 M40 C20
B Y50 M20 C70
C Y40 M70 C60

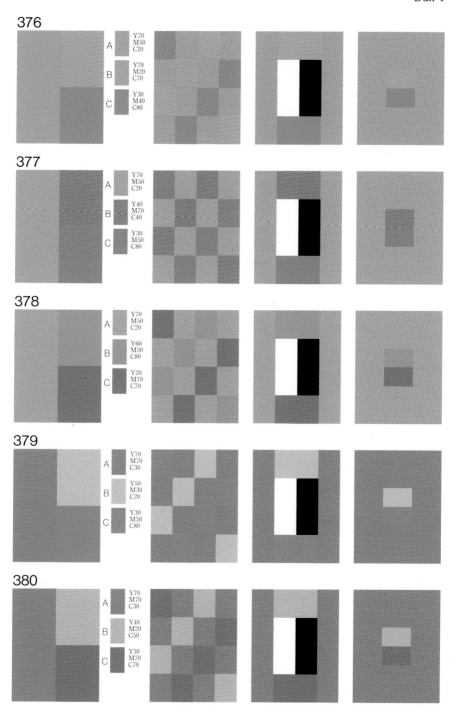

376

A Y70 M50 C20

B Y70 M20 C70

C Y30 M40 C80

377

A Y70 M50 C20

B Y40 M70 C40

C Y30 M50 C80

378

A Y70 M50 C20

B Y60 M30 C80

C Y20 M70 C70

379

A Y70 M70 C30

B Y50 M30 C20

C Y30 M50 C80

380

A Y70 M70 C30

B Y40 M20 C50

C Y30 M70 C70

381

382

383

384

385

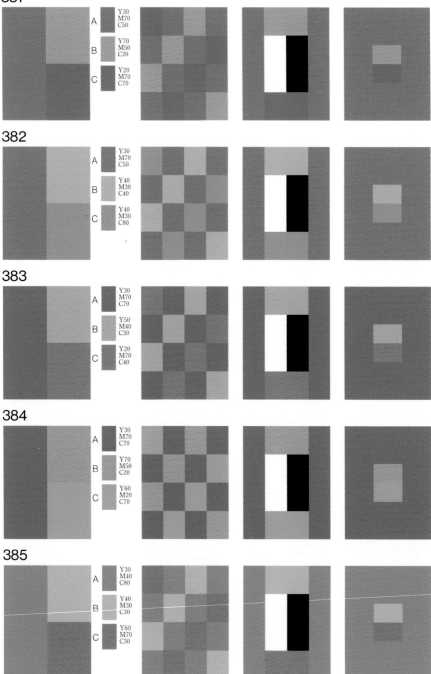

A	Y30 M70 C50
B	Y70 M50 C20
C	Y20 M70 C70

A	Y30 M70 C50
B	Y40 M30 C40
C	Y40 M30 C80

A	Y30 M70 C70
B	Y50 M40 C30
C	Y20 M70 C40

A	Y30 M70 C70
B	Y70 M50 C20
C	Y60 M20 C70

A	Y30 M40 C80
B	Y40 M30 C30
C	Y60 M70 C30

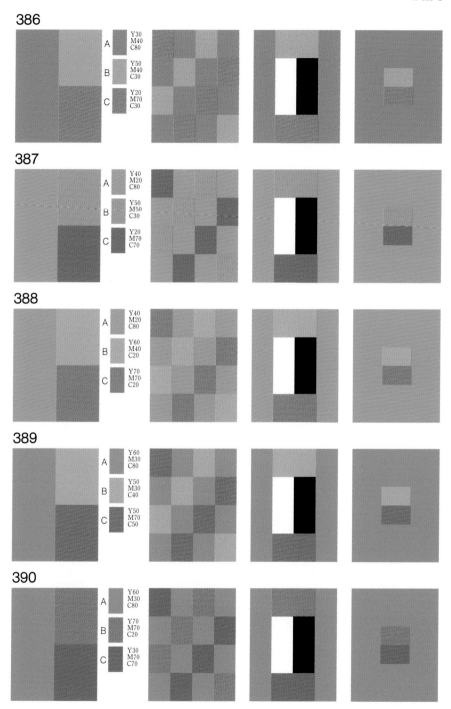

386

A Y30 M40 C80
B Y50 M40 C30
C Y20 M70 C30

387

A Y40 M20 C80
B Y50 M50 C30
C Y20 M70 C70

388

A Y40 M20 C80
B Y60 M40 C20
C Y70 M70 C20

389

A Y60 M30 C80
B Y50 M30 C40
C Y50 M70 C50

390

A Y60 M30 C80
B Y70 M70 C20
C Y30 M70 C70

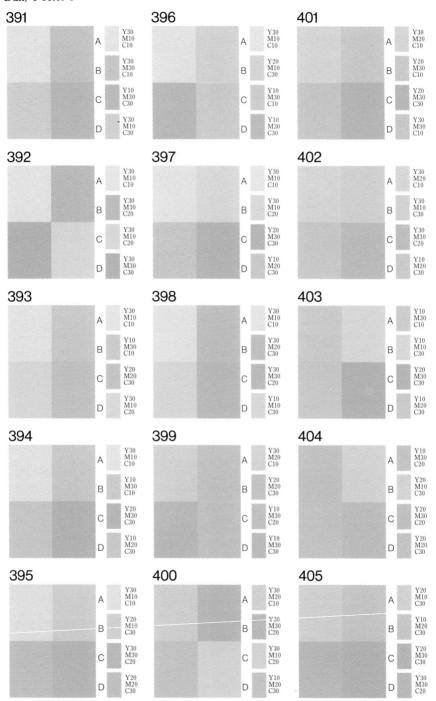

391

A Y30 M10 C10
B Y30 M30 C10
C Y10 M30 C30
D Y30 M10 C30

396

A Y30 M10 C10
B Y20 M10 C30
C Y10 M30 C10
D Y10 M30 C30

401

A Y30 M20 C10
B Y20 M30 C10
C Y20 M30 C30
D Y30 M30 C10

392

A Y30 M10 C10
B Y30 M30 C20
C Y30 M10 C20
D Y30 M30 C30

397

A Y30 M10 C10
B Y30 M10 C20
C Y20 M30 C30
D Y10 M20 C30

402

A Y30 M20 C10
B Y30 M10 C30
C Y30 M30 C20
D Y10 M20 C30

393

A Y30 M10 C10
B Y10 M30 C10
C Y20 M20 C30
D Y30 M10 C20

398

A Y30 M10 C10
B Y30 M20 C30
C Y30 M30 C20
D Y10 M10 C30

403

A Y10 M30 C10
B Y10 M10 C30
C Y20 M30 C30
D Y10 M20 C30

394

A Y30 M10 C10
B Y10 M30 C10
C Y20 M30 C30
D Y10 M20 C30

399

A Y30 M20 C10
B Y20 M20 C30
C Y10 M30 C20
D Y10 M30 C30

404

A Y10 M30 C20
B Y20 M10 C30
C Y20 M30 C20
D Y20 M20 C30

395

A Y30 M10 C10
B Y20 M10 C30
C Y30 M30 C20
D Y20 M20 C30

400

A Y30 M20 C10
B Y30 M30 C20
C Y30 M10 C20
D Y10 M20 C30

405

A Y20 M10 C30
B Y10 M20 C30
C Y20 M30 C30
D Y30 M30 C20

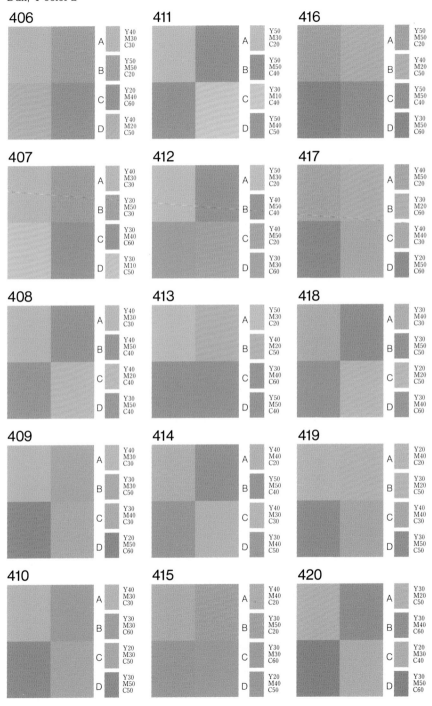

406
A Y40 M30 C30
B Y50 M50 C20
C Y20 M40 C60
D Y40 M20 C50

411
A Y50 M30 C20
B Y50 M50 C40
C Y30 M10 C40
D Y50 M40 C50

416
A Y50 M50 C20
B Y40 M20 C50
C Y50 M50 C40
D Y30 M40 C60

407
A Y40 M30 C30
B Y30 M50 C30
C Y30 M40 C60
D Y30 M10 C50

412
A Y50 M30 C20
B Y40 M50 C40
C Y40 M50 C20
D Y30 M30 C60

417
A Y40 M50 C20
B Y30 M20 C60
C Y40 M40 C30
D Y20 M50 C60

408
A Y40 M30 C30
B Y40 M50 C40
C Y40 M20 C40
D Y30 M50 C40

413
A Y50 M30 C20
B Y40 M20 C50
C Y30 M40 C60
D Y50 M50 C40

418
A Y30 M40 C30
B Y30 M50 C50
C Y20 M20 C50
D Y30 M40 C60

409
A Y40 M30 C30
B Y30 M30 C50
C Y30 M40 C30
D Y20 M50 C60

414
A Y40 M40 C20
B Y50 M50 C40
C Y40 M30 C30
D Y30 M40 C50

419
A Y20 M40 C20
B Y30 M20 C50
C Y40 M40 C30
D Y30 M50 C50

410
A Y40 M30 C30
B Y30 M30 C60
C Y20 M30 C50
D Y30 M50 C50

415
A Y40 M40 C20
B Y30 M50 C20
C Y30 M30 C60
D Y20 M40 C50

420
A Y30 M20 C50
B Y30 M40 C60
C Y20 M30 C40
D Y30 M50 C60

Dull, 4-color 3

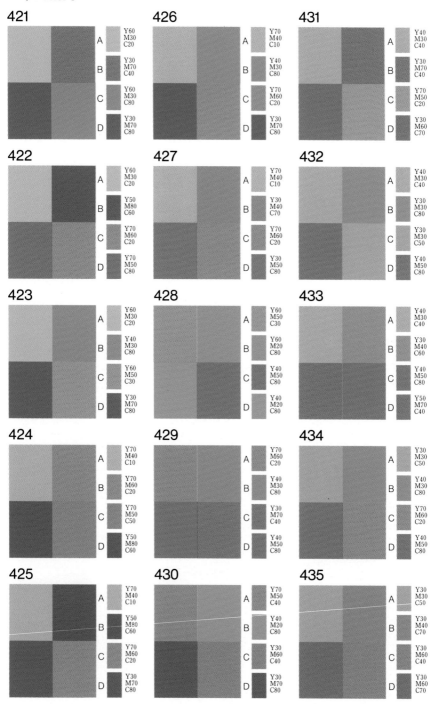

421

A Y60 M30 C20
B Y30 M70 C40
C Y60 M30 C80
D Y30 M70 C80

422

A Y60 M30 C20
B Y50 M80 C60
C Y70 M60 C20
D Y70 M50 C80

423

A Y60 M30 C20
B Y40 M30 C80
C Y60 M50 C30
D Y30 M70 C80

424

A Y70 M40 C10
B Y70 M60 C20
C Y70 M50 C50
D Y50 M80 C60

425

A Y70 M40 C10
B Y50 M80 C60
C Y70 M60 C20
D Y30 M70 C80

426

A Y70 M40 C10
B Y40 M30 C80
C Y70 M60 C20
D Y30 M70 C80

427

A Y70 M40 C10
B Y40 M40 C70
C Y70 M60 C20
D Y30 M50 C80

428

A Y60 M50 C30
B Y60 M20 C80
C Y40 M50 C80
D Y40 M20 C80

429

A Y70 M60 C20
B Y40 M30 C80
C Y30 M70 C40
D Y40 M50 C80

430

A Y70 M50 C40
B Y40 M20 C80
C Y30 M60 C40
D Y30 M70 C80

431

A Y40 M30 C40
B Y30 M70 C40
C Y70 M50 C20
D Y30 M60 C70

432

A Y40 M30 C40
B Y30 M30 C80
C Y30 M30 C50
D Y40 M50 C80

433

A Y40 M30 C40
B Y30 M40 C60
C Y40 M50 C80
D Y50 M70 C40

434

A Y30 M30 C50
B Y40 M30 C80
C Y70 M60 C20
D Y40 M50 C80

435

A Y30 M30 C50
B Y30 M40 C70
C Y30 M60 C40
D Y30 M60 C70

Dull, Gradation

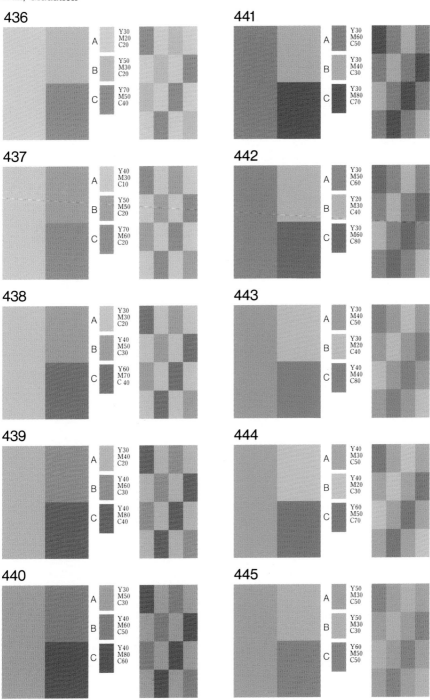

436

A — Y30 M20 C20
B — Y50 M30 C20
C — Y70 M50 C40

441

A — Y30 M60 C50
B — Y30 M40 C30
C — Y30 M80 C70

437

A — Y40 M30 C10
B — Y50 M50 C20
C — Y70 M60 C20

442

A — Y30 M50 C60
B — Y20 M30 C40
C — Y30 M60 C80

438

A — Y30 M30 C20
B — Y40 M50 C30
C — Y60 M70 C 40

443

A — Y30 M40 C50
B — Y30 M20 C40
C — Y40 M40 C80

439

A — Y30 M40 C20
B — Y40 M60 C30
C — Y40 M80 C40

444

A — Y40 M30 C50
B — Y40 M20 C30
C — Y60 M50 C70

440

A — Y30 M50 C30
B — Y40 M60 C50
C — Y40 M80 C60

445

A — Y50 M30 C50
B — Y50 M30 C30
C — Y60 M50 C50

55

446

A Y40 M20 C20
B Y80 M80 C20
C Y80 M40 C80

447

A Y40 M20 C20
B Y70 M80 C20
C Y50 M50 C80

448

A Y40 M20 C20
B Y30 M70 C40
C Y30 M70 C80

449

A Y40 M30 C10
B Y80 M50 C20
C Y80 M40 C80

450

A Y40 M30 C10
B Y70 M80 C20
C Y30 M70 C80

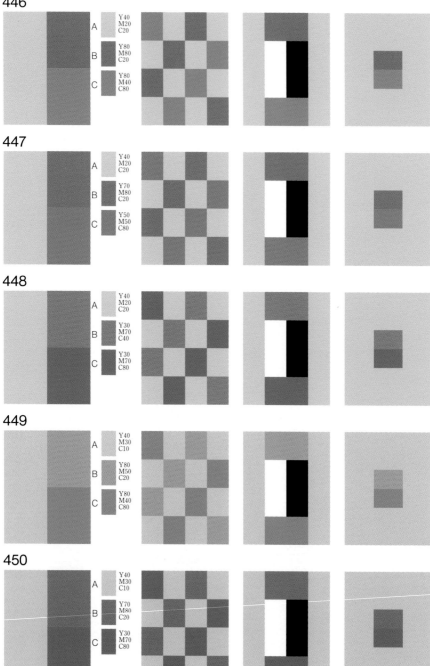

451

A
Y30
M30
C30

B
Y80
M70
C20

C
Y40
M30
C80

452

A
Y30
M30
C30

B
Y70
M80
C20

C
Y30
M50
C80

453

A
Y30
M30
C30

B
Y20
M70
C40

C
Y30
M50
C80

454

A
Y30
M30
C30

B
Y50
M50
C80

C
Y50
M80
C60

455

A
Y30
M30
C30

B
Y40
M30
C80

C
Y30
M70
C80

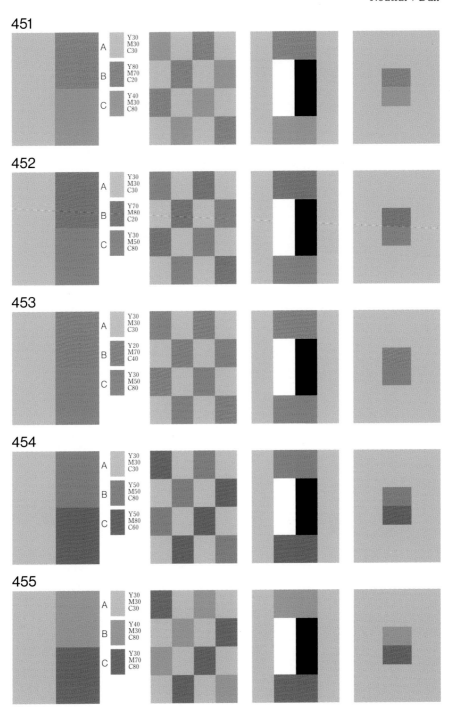

456

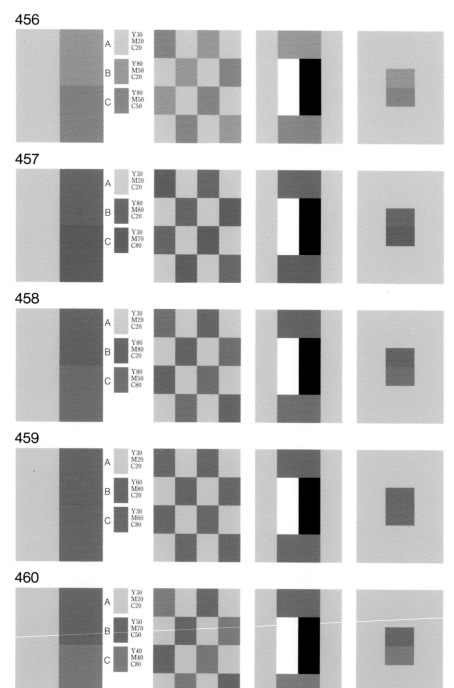

A Y30 M20 C20
B Y80 M50 C20
C Y80 M50 C50

457

A Y30 M20 C20
B Y80 M80 C20
C Y30 M70 C80

458

A Y30 M20 C20
B Y80 M80 C20
C Y80 M50 C80

459

A Y30 M20 C20
B Y60 M80 C20
C Y30 M60 C80

460

A Y30 M20 C20
B Y50 M70 C50
C Y40 M40 C80

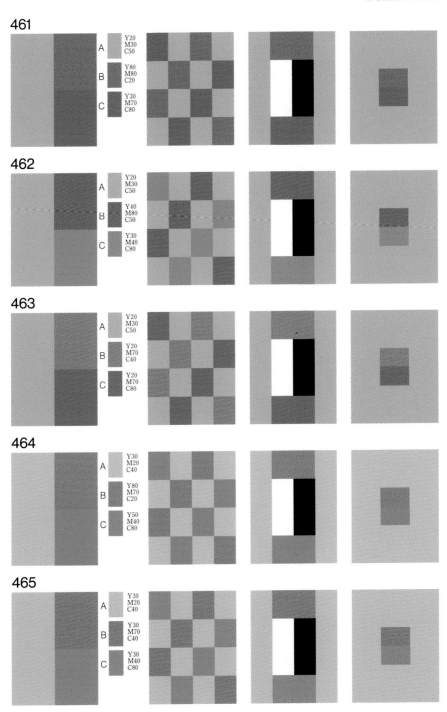

461

A Y20 M30 C50

B Y80 M80 C20

C Y30 M70 C80

462

A Y20 M30 C50

B Y40 M80 C50

C Y30 M40 C80

463

A Y20 M30 C50

B Y20 M70 C40

C Y20 M70 C80

464

A Y30 M20 C40

B Y80 M70 C20

C Y50 M40 C80

465

A Y30 M20 C40

B Y30 M70 C40

C Y30 M40 C80

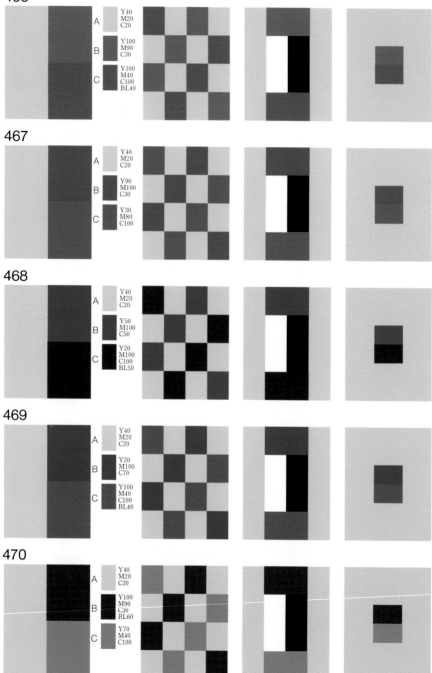

466

A
Y40
M20
C20

B
Y100
M90
C30

C
Y100
M40
C100
BL40

467

A
Y40
M20
C20

B
Y90
M100
C30

C
Y30
M80
C100

468

A
Y40
M20
C20

B
Y50
M100
C50

C
Y20
M100
C100
BL50

469

A
Y40
M20
C20

B
Y20
M100
C70

C
Y100
M40
C100
BL40

470

A
Y40
M20
C20

B
Y100
M90
C30
BL60

C
Y70
M40
C100

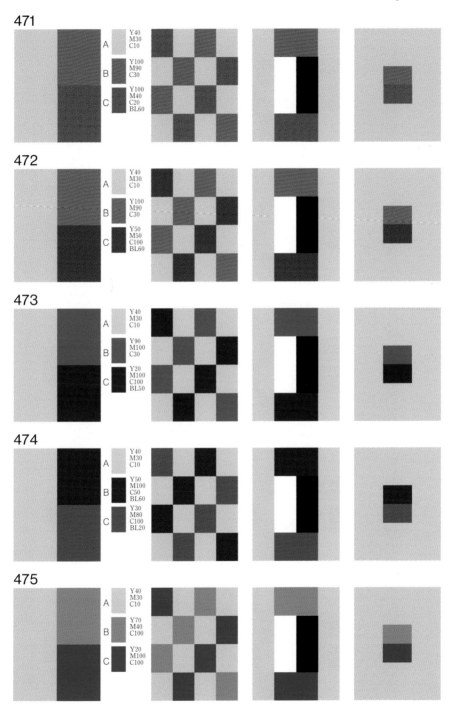

471
A Y40 M30 C10
B Y100 M90 C30
C Y100 M40 C20 BL60

472
A Y40 M30 C10
B Y100 M90 C30
C Y50 M50 C100 BL60

473
A Y40 M30 C10
B Y90 M100 C30
C Y20 M100 C100 BL50

474
A Y40 M30 C10
B Y50 M100 C50 BL60
C Y30 M80 C100 BL20

475
A Y40 M30 C10
B Y70 M40 C100
C Y20 M100 C100

476

A — Y30 M20 C20
B — Y100 M90 C30
C — Y20 M100 C100 BL50

477

A — Y30 M20 C20
B — Y90 M100 C30
C — Y20 M100 C100

478

A — Y30 M20 C20
B — Y50 M100 C50
C — Y100 M40 C20 BL60

479

A — Y30 M20 C20
B — Y50 M100 C50
C — Y50 M50 C100 BL60

480

A — Y30 M20 C20
B — Y50 M50 C100
C — Y50 M100 C50 BL60

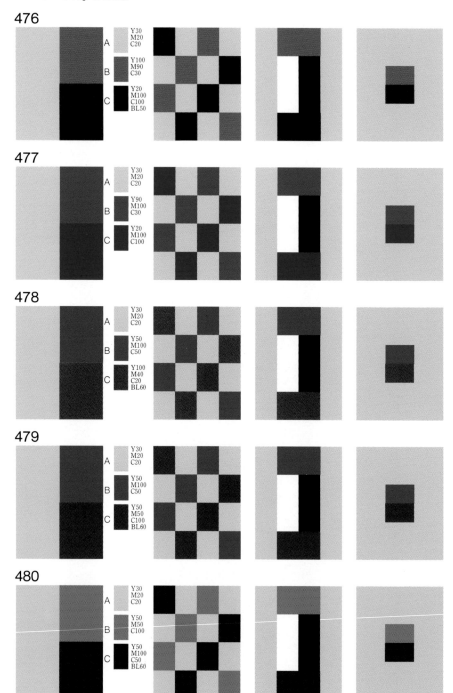

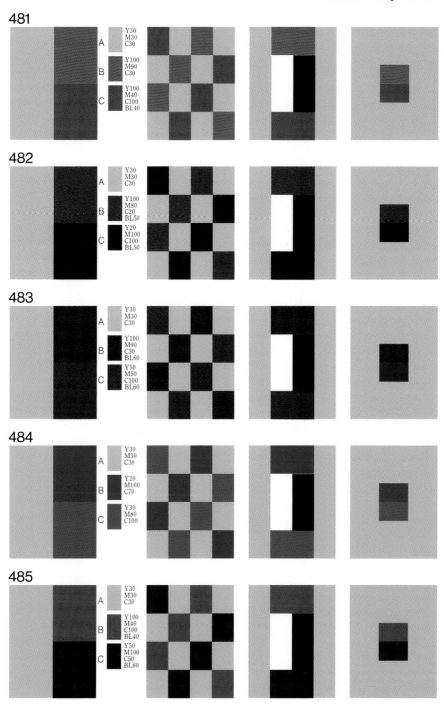

481

A Y30 M30 C30

B Y100 M90 C30

C Y100 M40 C100 BL40

482

A Y30 M30 C30

B Y100 M80 C20 BL50

C Y20 M100 C100 BL50

483

A Y30 M30 C30

B Y100 M90 C30 BL60

C Y50 M50 C100 BL60

484

A Y30 M30 C30

B Y20 M100 C70

C Y30 M80 C100

485

A Y30 M30 C30

B Y100 M40 C100 BL40

C Y50 M100 C50 BL60

Neutral + Deep & Dark

486

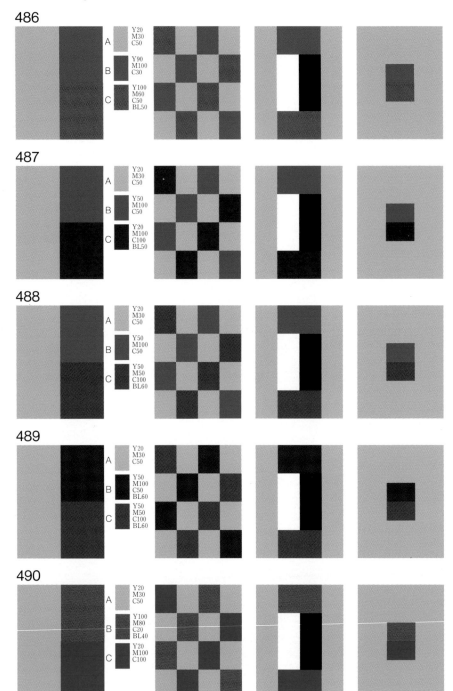

A Y20 M30 C50
B Y90 M100 C30
C Y100 M60 C50 BL50

487

A Y20 M30 C50
B Y50 M100 C50
C Y20 M100 C100 BL50

488

A Y20 M30 C50
B Y50 M100 C50
C Y50 M50 C100 BL60

489

A Y20 M30 C50
B Y50 M100 C50 BL60
C Y50 M50 C100 BL60

490

A Y20 M30 C50
B Y100 M80 C20 BL40
C Y20 M100 C100

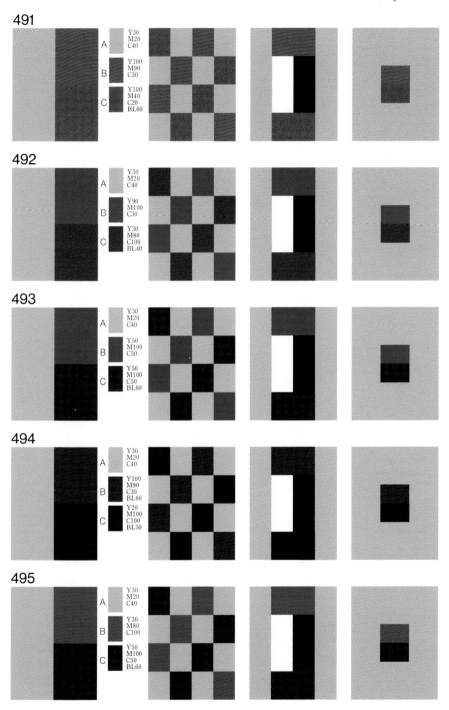

491

A — Y30 M20 C40
B — Y100 M90 C30
C — Y100 M40 C20 BL60

492

A — Y30 M20 C40
B — Y90 M100 C30
C — Y30 M80 C100 BL40

493

A — Y30 M20 C40
B — Y50 M100 C50
C — Y50 M100 C50 BL60

494

A — Y30 M20 C40
B — Y100 M90 C30 BL60
C — Y20 M100 C100 BL50

495

A — Y30 M20 C40
B — Y30 M80 C100
C — Y50 M100 C50 BL60

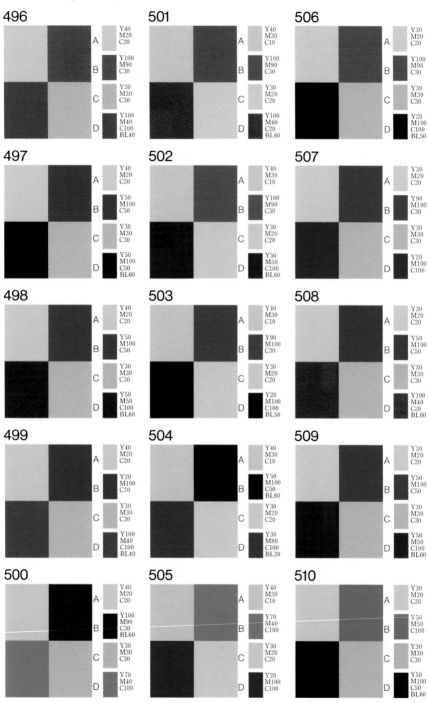

496
A Y40 M20 C20
B Y100 M90 C30
C Y30 M30 C30
D Y100 M40 C100 BL40

501
A Y40 M30 C10
B Y100 M90 C30
C Y20 M20 C20
D Y100 M40 C20 BL60

506
A Y30 M20 C20
B Y100 M90 C30
C Y30 M30 C30
D Y20 M100 C100 BL50

497
A Y40 M20 C20
B Y50 M100 C50
C Y30 M30 C30
D Y50 M100 C50 BL60

502
A Y40 M30 C10
B Y100 M90 C30
C Y30 M20 C20
D Y50 M50 C100 BL60

507
A Y30 M20 C20
B Y90 M100 C30
C Y30 M30 C30
D Y20 M100 C100

498
A Y40 M20 C20
B Y50 M100 C50
C Y30 M30 C30
D Y50 M50 C100 BL60

503
A Y40 M30 C10
B Y90 M100 C30
C Y30 M20 C20
D Y20 M100 C100 BL50

508
A Y30 M20 C20
B Y50 M100 C50
C Y30 M30 C30
D Y100 M40 C20 BL60

499
A Y40 M20 C20
B Y20 M100 C70
C Y30 M30 C30
D Y100 M40 C100 BL40

504
A Y40 M30 C10
B Y50 M100 C50 BL60
C Y30 M20 C20
D Y30 M80 C100 BL20

509
A Y30 M20 C20
B Y50 M100 C50
C Y30 M30 C30
D Y50 M50 C100 BL60

500
A Y40 M20 C20
B Y100 M90 C30 BL60
C Y30 M30 C30
D Y70 M40 C100

505
A Y40 M30 C10
B Y70 M40 C100
C Y30 M20 C20
D Y20 M100 C100

510
A Y30 M20 C20
B Y50 M50 C100
C Y30 M30 C30
D Y50 M100 C50 BL60

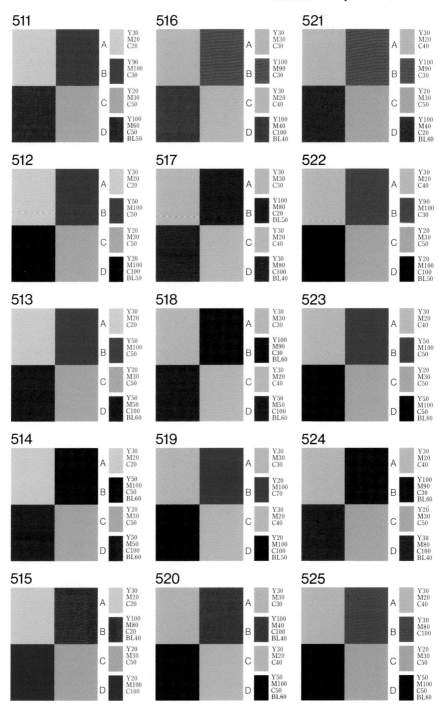

511
- A Y30 M20 C20
- B Y90 M100 C30
- C Y20 M30 C50
- D Y100 M60 C50 BL50

516
- A Y30 M30 C30
- B Y100 M90 C30
- C Y30 M20 C40
- D Y100 M40 C100 BL40

521
- A Y30 M20 C40
- B Y100 M90 C30
- C Y20 M30 C50
- D Y100 M40 C20 BL60

512
- A Y30 M20 C20
- B Y50 M100 C50
- C Y20 M30 C50
- D Y20 M100 C100 BL50

517
- A Y30 M30 C30
- B Y100 M80 C20 BL50
- C Y30 M20 C40
- D Y30 M80 C100 BL40

522
- A Y30 M20 C40
- B Y90 M100 C30
- C Y20 M30 C50
- D Y20 M100 C100 BL50

513
- A Y30 M20 C20
- B Y50 M100 C50
- C Y20 M30 C50
- D Y50 M50 C100 BL60

518
- A Y30 M30 C30
- B Y100 M90 C30 BL60
- C Y30 M20 C40
- D Y50 M50 C100 BL60

523
- A Y30 M20 C40
- B Y50 M100 C50
- C Y20 M30 C50
- D Y50 M100 C50 BL60

514
- A Y30 M20 C20
- B Y50 M100 C50 BL60
- C Y20 M30 C50
- D Y50 M50 C100 BL60

519
- A Y30 M30 C30
- B Y20 M100 C70
- C Y30 M20 C40
- D Y20 M100 C100 BL50

524
- A Y30 M20 C40
- B Y100 M90 C30 BL60
- C Y20 M30 C50
- D Y30 M80 C100 BL40

515
- A Y30 M20 C20
- B Y100 M80 C20 BL40
- C Y20 M30 C40
- D Y20 M100 C100

520
- A Y30 M30 C30
- B Y100 M40 C100 BL40
- C Y30 M20 C40
- D Y50 M100 C50 BL60

525
- A Y30 M20 C40
- B Y30 M80 C100
- C Y20 M30 C50
- D Y50 M100 C50 BL60

vivid
deep

Vivid tones are compatible with dull, dark, and grayish colors, but are difficult to combine with pastels. They are put to best use, however, when used alone. When they are combined with natural colors such as brown and darker hues, a feeling of depth is imparted to the overall pattern. To create vivid tones, two of the three primary colors employed in printing are mixed together, and one of these two must be at 100 percent.

Deep tones use all three of the printer's primary colors. Dull, dark, and grayish tones, which contain the same three colors, complement the deep tones well. It is possible to make deep tones by adding black to the density figures of the chart of vivid colors.

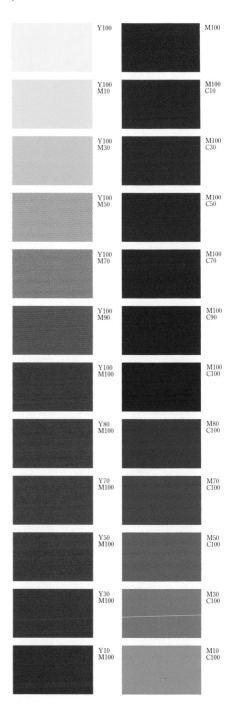

C100	Y100 M20 C10	Y20 M100 C20	Y20 M20 C100
Y10 C100	Y100 M30 C20	Y20 M100 C30	Y40 M20 C100
Y30 C100	Y100 M50 C20	Y20 M100 C50	Y50 M30 C100
Y50 C100	Y100 M60 C20	Y20 M100 C60	Y60 M30 C100
Y70 C100	Y100 M70 C30	Y20 M100 C70	Y70 M30 C100
Y80 C100	Y100 M90 C30	Y20 M100 C90	Y80 M30 C100
Y100 C100	Y100 M100 C30	Y20 M100 C100	Y100 M30 C100
Y100 C80	Y90 M100 C30	Y20 M90 C100	Y100 M20 C90
Y100 C70	Y70 M100 C30	Y20 M70 C100	Y100 M20 C70
Y100 C50	Y60 M100 C30	Y20 M60 C100	Y100 M20 C50
Y100 C30	Y50 M100 C30	Y20 M50 C100	Y100 M20 C40
Y100 C10	Y30 M100 C20	Y20 M30 C100	Y100 M20 C30

69

Vivid

526

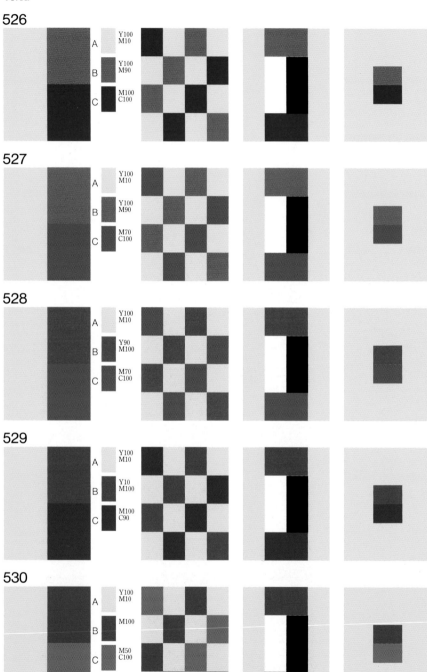

A	Y100 M10
B	Y100 M90
C	M100 C100

527

A	Y100 M10
B	Y100 M90
C	M70 C100

528

A	Y100 M10
B	Y90 M100
C	M70 C100

529

A	Y100 M10
B	Y10 M100
C	M100 C90

530

A	Y100 M10
B	M100
C	M50 C100

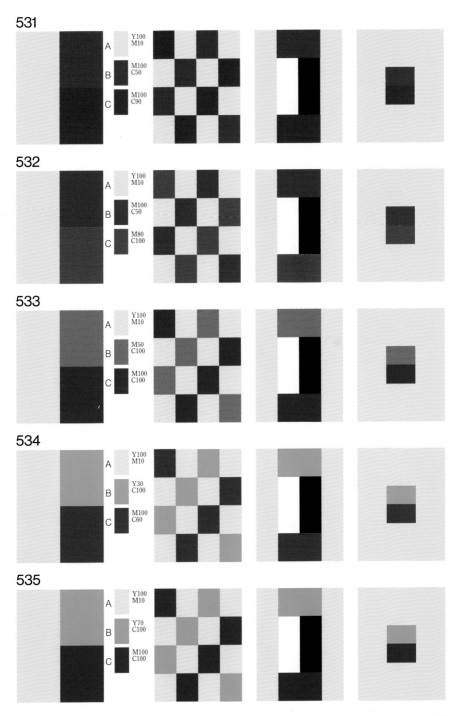

531

A — Y100 M10
B — M100 C50
C — M100 C90

532

A — Y100 M10
B — M100 C50
C — M80 C100

533

A — Y100 M10
B — M50 C100
C — M100 C100

534

A — Y100 M10
B — Y30 C100
C — M100 C60

535

A — Y100 M10
B — Y70 C100
C — M100 C100

Vivid

536

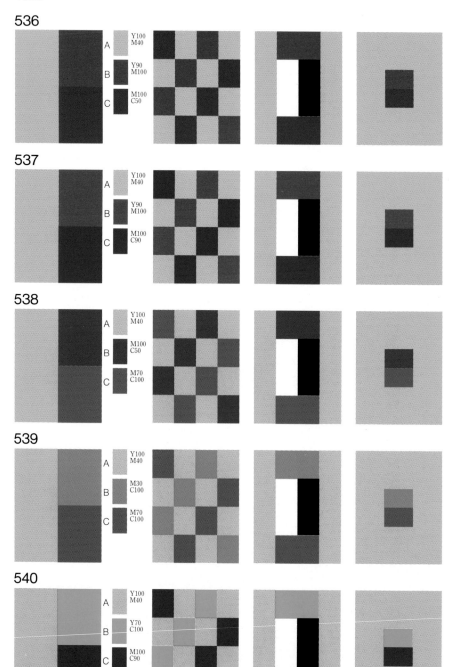

A Y100 M40
B Y90 M100
C M100 C50

537

A Y100 M40
B Y90 M100
C M100 C90

538

A Y100 M40
B M100 C50
C M70 C100

539

A Y100 M40
B M30 C100
C M70 C100

540

A Y100 M40
B Y70 C100
C M100 C90

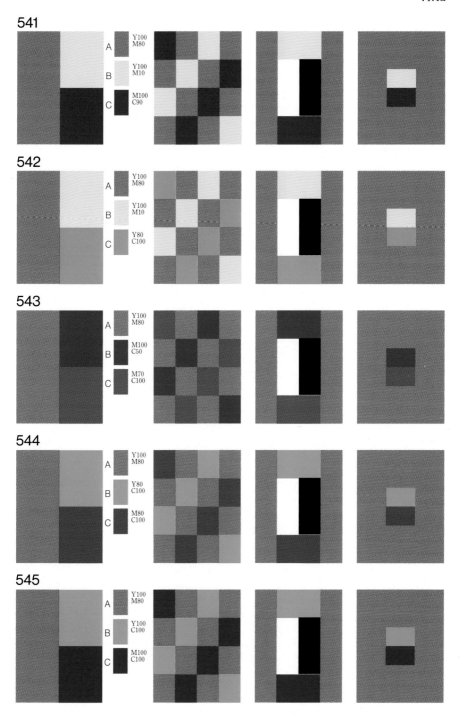

541

A — Y100 M80
B — Y100 M10
C — M100 C90

542

A — Y100 M80
B — Y100 M10
C — Y80 C100

543

A — Y100 M80
B — M100 C50
C — M70 C100

544

A — Y100 M80
B — Y80 C100
C — M80 C100

545

A — Y100 M80
B — Y100 C100
C — M100 C100

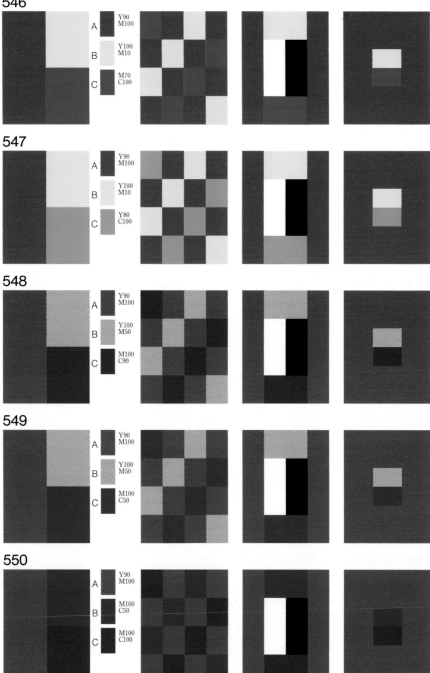

546

A — Y90 M100
B — Y100 M10
C — M70 C100

547

A — Y90 M100
B — Y100 M10
C — Y80 C100

548

A — Y90 M100
B — Y100 M50
C — M100 C90

549

A — Y90 M100
B — Y100 M50
C — M100 C50

550

A — Y90 M100
B — M100 C50
C — M100 C100

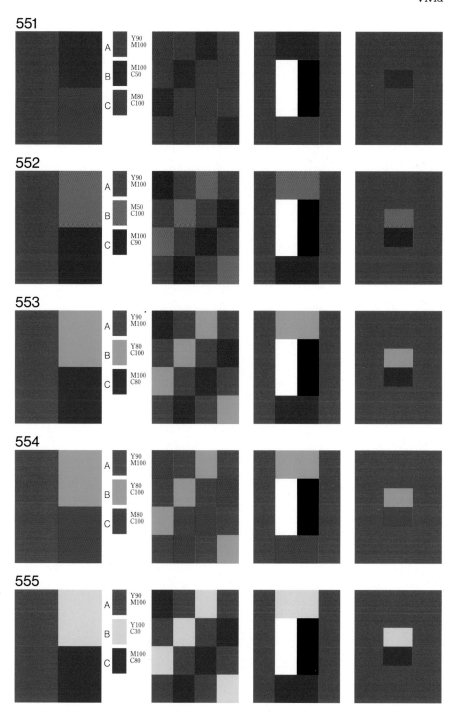

551
A Y90 M100
B M100 C50
C M80 C100

552
A Y90 M100
B M50 C100
C M100 C90

553
A Y90 M100
B Y80 C100
C M100 C80

554
A Y90 M100
B Y80 C100
C M80 C100

555
A Y90 M100
B Y100 C30
C M100 C80

Vivid

556

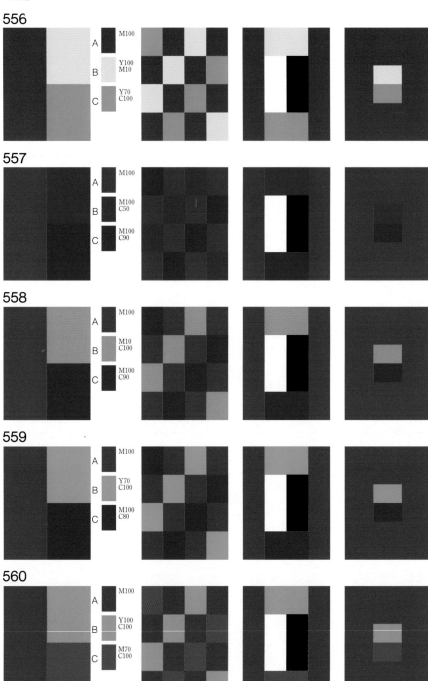

A — M100
B — Y100 M10
C — Y70 C100

557

A — M100
B — M100 C50
C — M100 C90

558

A — M100
B — M10 C100
C — M100 C90

559

A — M100
B — Y70 C100
C — M100 C80

560

A — M100
B — Y100 C100
C — M70 C100

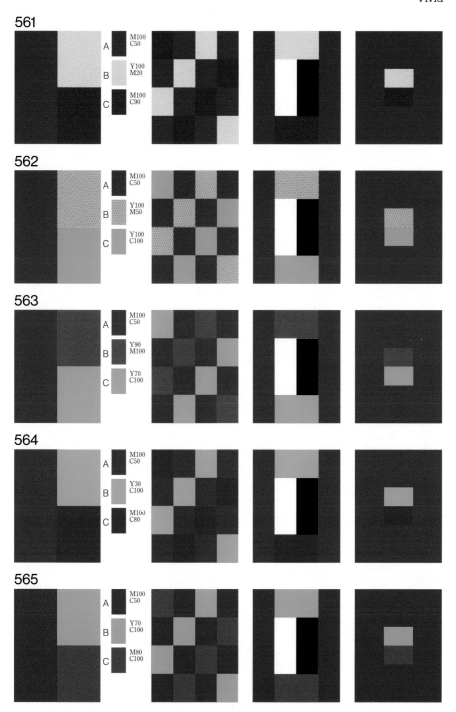

561

A M100 C50
B Y100 M20
C M100 C90

562

A M100 C50
B Y100 M50
C Y100 C100

563

A M100 C50
B Y90 M100
C Y70 C100

564

A M100 C50
B Y30 C100
C M100 C80

565

A M100 C50
B Y70 C100
C M80 C100

566

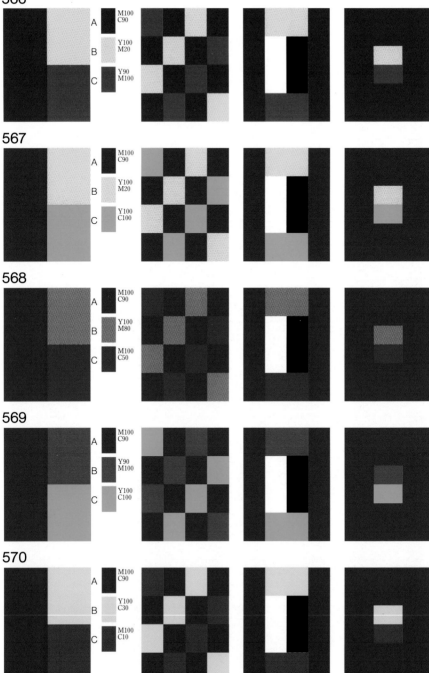

A M100 C90

B Y100 M20

C Y90 M100

567

A M100 C90

B Y100 M20

C Y100 C100

568

A M100 C90

B Y100 M80

C M100 C50

569

A M100 C90

B Y90 M100

C Y100 C100

570

A M100 C90

B Y100 C30

C M100 C10

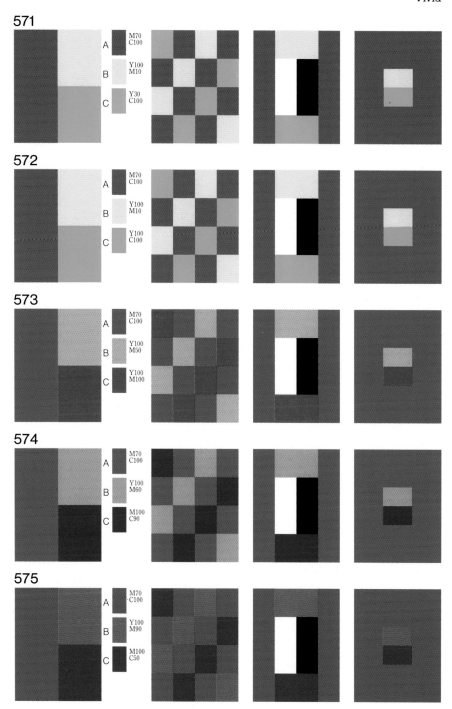

Vivid

576

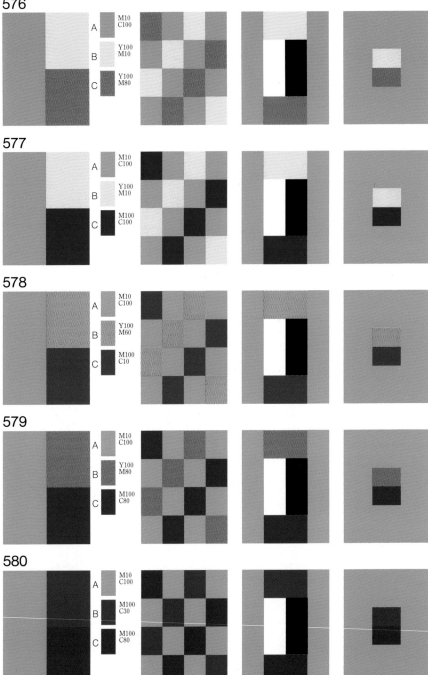

A M10 C100
B Y100 M10
C Y100 M80

577

A M10 C100
B Y100 M10
C M100 C100

578

A M10 C100
B Y100 M60
C M100 C10

579

A M10 C100
B Y100 M80
C M100 C80

580

A M10 C100
B M100 C30
C M100 C80

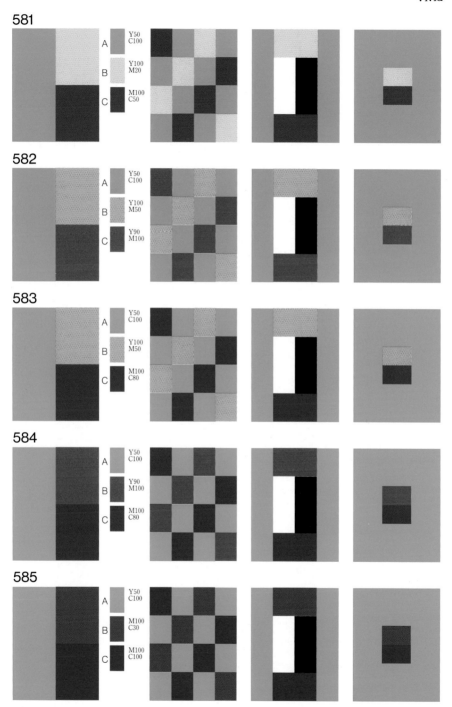

581

A Y50 C100
B Y100 M20
C M100 C50

582

A Y50 C100
B Y100 M50
C Y90 M100

583

A Y50 C100
B Y100 M50
C M100 C80

584

A Y50 C100
B Y90 M100
C M100 C80

585

A Y50 C100
B M100 C30
C M100 C100

Vivid

586

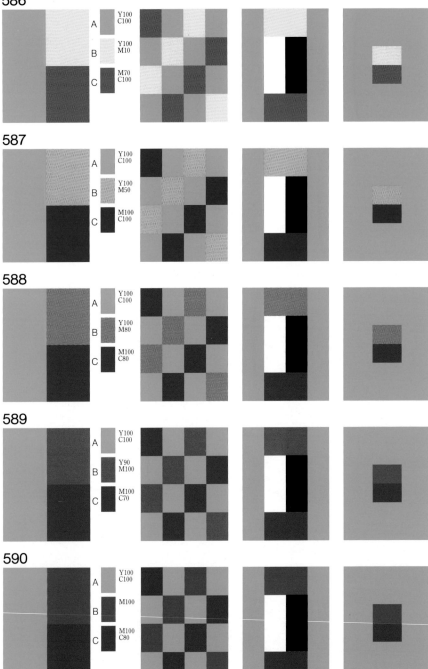

A — Y100 C100
B — Y100 M10
C — M70 C100

587

A — Y100 C100
B — Y100 M50
C — M100 C100

588

A — Y100 C100
B — Y100 M80
C — M100 C80

589

A — Y100 C100
B — Y90 M100
C — M100 C70

590

A — Y100 C100
B — M100
C — M100 C80

82

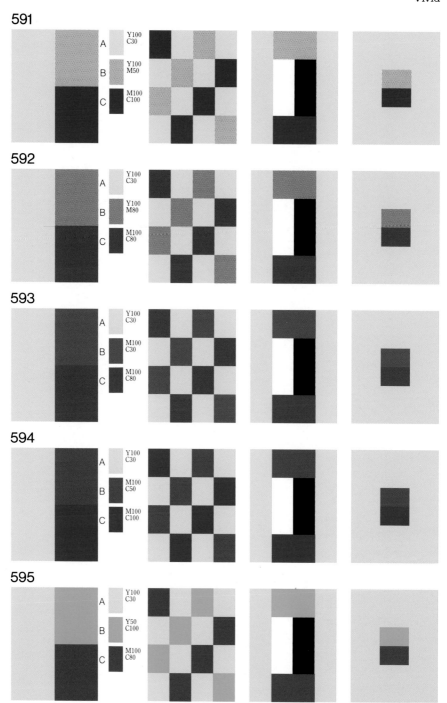

591

A Y100 C30
B Y100 M50
C M100 C100

592

A Y100 C30
B Y100 M80
C M100 C80

593

A Y100 C30
B M100 C30
C M100 C80

594

A Y100 C30
B M100 C50
C M100 C100

595

A Y100 C30
B Y50 C100
C M100 C80

Vivid, Gradation

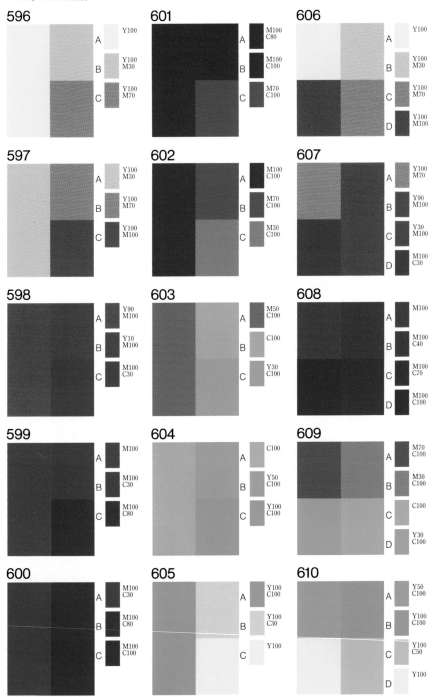

596
A Y100
B Y100 M30
C Y100 M70

597
A Y100 M30
B Y100 M70
C Y100 M100

598
A Y90 M100
B Y10 M100
C M100 C30

599
A M100
B M100 C30
C M100 C80

600
A M100 C30
B M100 C80
C M100 C100

601
A M100 C80
B M100 C100
C M70 C100

602
A M100 C100
B M70 C100
C M30 C100

603
A M50 C100
B C100
C Y30 C100

604
A C100
B Y50 C100
C Y100 C100

605
A Y100 C100
B Y100 C30
C Y100

606
A Y100
B Y100 M30
C Y100 M70
D Y100 M100

607
A Y100 M70
B Y90 M100
C Y30 M100
D M100 C30

608
A M100
B M100 C40
C M100 C70
D M100 C100

609
A M70 C100
B M30 C100
C C100
D Y30 C100

610
A Y50 C100
B Y100 C100
C Y100 C50
D Y100

84

Vivid, 4-color

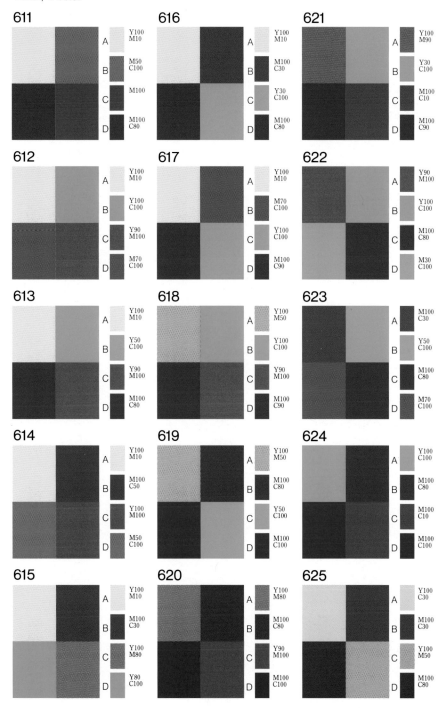

611
A Y100 M10
B M50 C100
C M100
D M100 C80

616
A Y100 M10
B M100 C30
C Y30 C100
D M100 C80

621
A Y100 M90
B Y30 C100
C M100 C10
D M100 C90

612
A Y100 M10
B Y100 C100
C Y90 M100
D M70 C100

617
A Y100 M10
B M70 C100
C Y100 C100
D M100 C90

622
A Y90 M100
B Y100 C100
C M100 C80
D M30 C100

613
A Y100 M10
B Y50 C100
C Y90 M100
D M100 C80

618
A Y100 M50
B Y100 C100
C Y90 M100
D M100 C90

623
A M100 C30
B Y50 C100
C M100 C80
D M70 C100

614
A Y100 M10
B M100 C50
C Y100 M100
D M50 C100

619
A Y100 M50
B M100 C80
C Y50 C100
D M100 C100

624
A Y100 C100
B M100 C80
C M100 C10
D M100 C100

615
A Y100 M10
B M100 C30
C Y100 M80
D Y80 C100

620
A Y100 M80
B M100 C80
C Y90 M100
D M100 C100

625
A Y100 C30
B M100 C30
C Y100 M50
D M100 C80

Vivid + Dark, 4-color

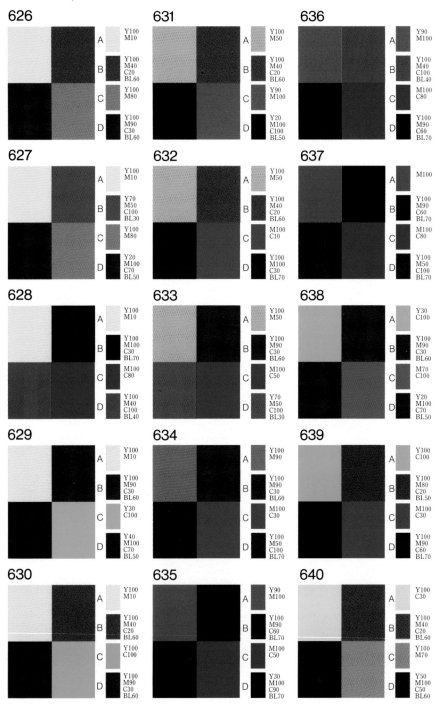

626
A — Y100 M10
B — Y100 M40 C20 BL60
C — Y100 M80
D — Y100 M90 C30 BL60

627
A — Y100 M10
B — Y70 M50 C100 BL30
C — Y100 M80
D — Y20 M100 C70 BL50

628
A — Y100 M10
B — Y100 M100 C30 BL70
C — M100 C80
D — Y100 M40 C100 BL40

629
A — Y100 M10
B — Y100 M90 C30 BL60
C — Y30 C100
D — Y40 M100 C70 BL50

630
A — Y100 M10
B — Y100 M40 C20 BL60
C — Y100 C100
D — Y100 M90 C30 BL60

631
A — Y100 M50
B — Y100 M40 C20 BL60
C — Y90 M100
D — Y20 M100 C100 BL50

632
A — Y100 M50
B — Y100 M40 C20 BL60
C — M100 C10
D — Y100 M100 C30 BL70

633
A — Y100 M50
B — Y100 M90 C30 BL60
C — M100 C50
D — Y70 M50 C100 BL30

634
A — Y100 M90
B — Y100 M90 C30 BL60
C — M100 C30
D — Y100 M50 C100 BL70

635
A — Y90 M100
B — Y100 M90 C60 BL70
C — M100 C50
D — Y30 M100 C90 BL70

636
A — Y90 M100
B — Y100 M40 C100 BL40
C — M100 C80
D — Y100 M90 C60 BL70

637
A — M100
B — Y100 M90 C60 BL70
C — M100 C80
D — Y100 M50 C100 BL70

638
A — Y30 C100
B — Y100 M90 C30 BL60
C — M70 C100
D — Y20 M100 C70 BL50

639
A — Y100 C100
B — Y100 M80 C20 BL50
C — M100 C30
D — Y100 M90 C60 BL70

640
A — Y100 C30
B — Y100 M40 C20 BL60
C — Y100 M70
D — Y50 M100 C50 BL60

Vivid + Grayish, 4-color

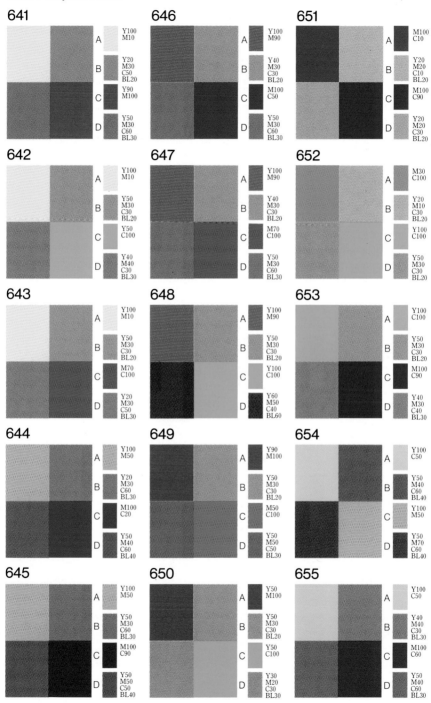

641

A — Y100 M10
B — Y20 M30 C50 BL20
C — Y90 M100
D — Y50 M30 C60 BL30

642

A — Y100 M10
B — Y50 M30 C30 BL20
C — Y50 C100
D — Y40 M40 C30 BL30

643

A — Y100 M10
B — Y50 M30 C30 BL20
C — M70 C100
D — Y20 M30 C50 BL30

644

A — Y100 M50
B — Y20 M30 C60 BL30
C — M100 C20
D — Y50 M40 C60 BL40

645

A — Y100 M50
B — Y50 M30 C60 BL30
C — M100 C90
D — Y50 M50 C50 BL40

646

A — Y100 M90
B — Y40 M30 C50 BL20
C — M100 C50
D — Y50 M30 C60 BL30

647

A — Y100 M90
B — Y40 M30 C30 BL20
C — M70 C100
D — Y50 M30 C60 BL30

648

A — Y100 M90
B — Y50 M30 C30 BL20
C — Y100 C100
D — Y60 M50 C40 BL60

649

A — Y90 M100
B — Y50 M30 C30 BL20
C — M50 C100
D — Y50 M50 C50 BL30

650

A — Y50 M100
B — Y50 M30 C30 BL20
C — Y50 C100
D — Y30 M20 C30 BL30

651

A — M100 C10
B — Y20 M20 C10 BL20
C — M100 C90
D — Y20 M20 C30 BL20

652

A — M30 C100
B — Y20 M10 C30 BL20
C — Y100 C100
D — Y50 M30 C30 BL20

653

A — Y100 C100
B — Y50 M30 C30 BL20
C — M100 C90
D — Y40 M30 C40 BL30

654

A — Y100 C50
B — Y50 M40 C60 BL40
C — Y100 M50
D — Y50 M70 C60 BL40

655

A — Y100 C50
B — Y40 M40 C30 BL30
C — M100 C60
D — Y50 M40 C60 BL30

656

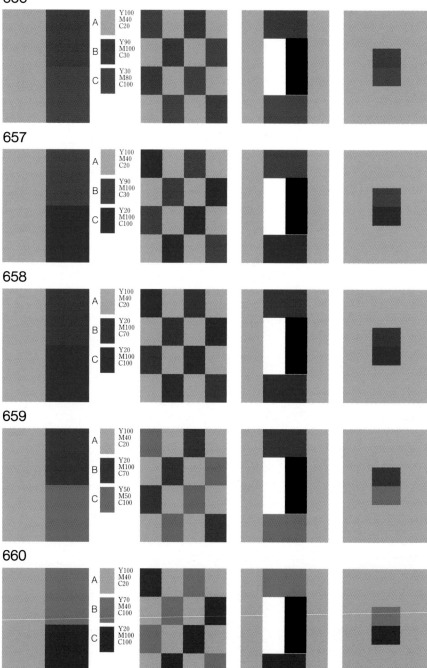

A	Y100 M40 C20
B	Y90 M100 C30
C	Y30 M80 C100

657

A	Y100 M40 C20
B	Y90 M100 C30
C	Y20 M100 C100

658

A	Y100 M40 C20
B	Y20 M100 C70
C	Y20 M100 C100

659

A	Y100 M40 C20
B	Y20 M100 C70
C	Y50 M50 C100

660

A	Y100 M40 C20
B	Y70 M40 C100
C	Y20 M100 C100

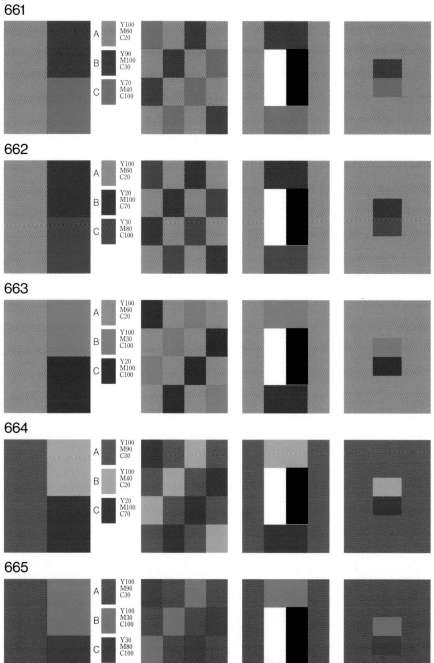

661

A: Y100 M60 C20
B: Y90 M100 C30
C: Y70 M40 C100

662

A: Y100 M60 C20
B: Y20 M100 C70
C: Y30 M80 C100

663

A: Y100 M60 C20
B: Y100 M30 C100
C: Y20 M100 C100

664

A: Y100 M90 C30
B: Y100 M40 C20
C: Y20 M100 C70

665

A: Y100 M90 C30
B: Y100 M30 C100
C: Y30 M80 C100

Deep

666

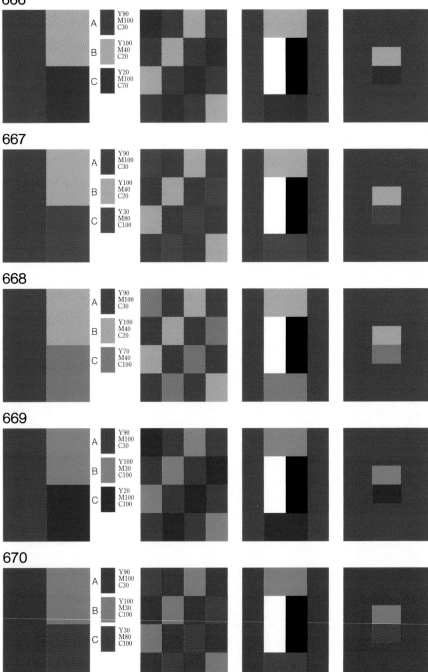

A Y90 M100 C30
B Y100 M40 C20
C Y20 M100 C70

667

A Y90 M100 C30
B Y100 M40 C20
C Y30 M80 C100

668

A Y90 M100 C30
B Y100 M40 C20
C Y70 M40 C100

669

A Y90 M100 C30
B Y100 M30 C100
C Y20 M100 C100

670

A Y90 M100 C30
B Y100 M30 C100
C Y30 M80 C100

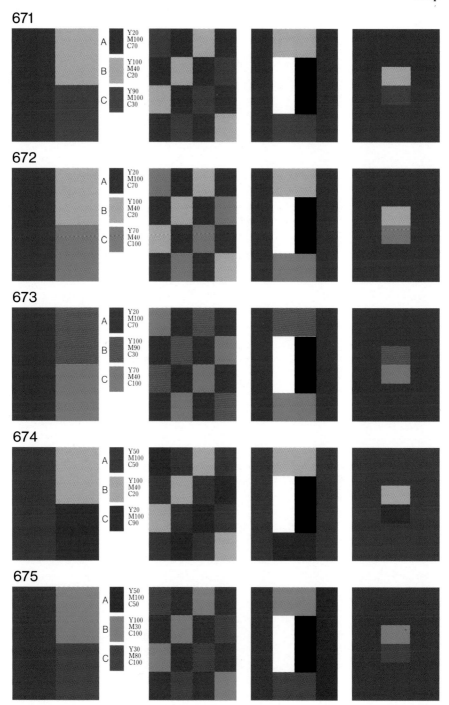

671

A Y20
 M100
 C70

B Y100
 M40
 C20

C Y90
 M100
 C30

672

A Y20
 M100
 C70

B Y100
 M40
 C20

C Y70
 M40
 C100

673

A Y20
 M100
 C70

B Y100
 M90
 C30

C Y70
 M40
 C100

674

A Y50
 M100
 C50

B Y100
 M40
 C20

C Y20
 M100
 C90

675

A Y50
 M100
 C50

B Y100
 M30
 C100

C Y30
 M80
 C100

Deep

676

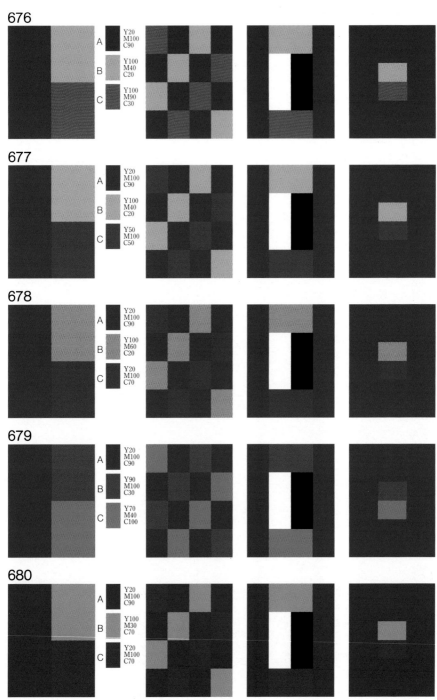

A Y20 M100 C90
B Y100 M40 C20
C Y100 M90 C30

677

A Y20 M100 C90
B Y100 M40 C20
C Y50 M100 C50

678

A Y20 M100 C90
B Y100 M60 C20
C Y20 M100 C70

679

A Y20 M100 C90
B Y90 M100 C30
C Y70 M40 C100

680

A Y20 M100 C90
B Y100 M30 C70
C Y20 M100 C70

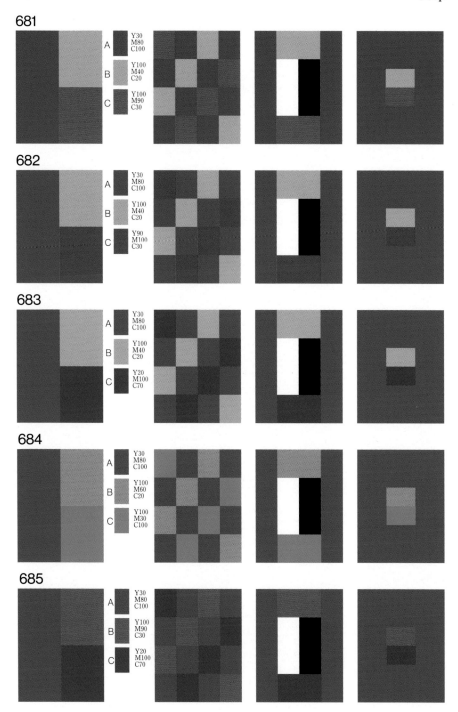

681

A — Y30 M80 C100
B — Y100 M40 C20
C — Y100 M90 C30

682

A — Y30 M80 C100
B — Y100 M40 C20
C — Y90 M100 C30

683

A — Y30 M80 C100
B — Y100 M40 C20
C — Y20 M100 C70

684

A — Y30 M80 C100
B — Y100 M60 C20
C — Y100 M30 C100

685

A — Y30 M80 C100
B — Y100 M90 C30
C — Y20 M100 C70

Deep

686

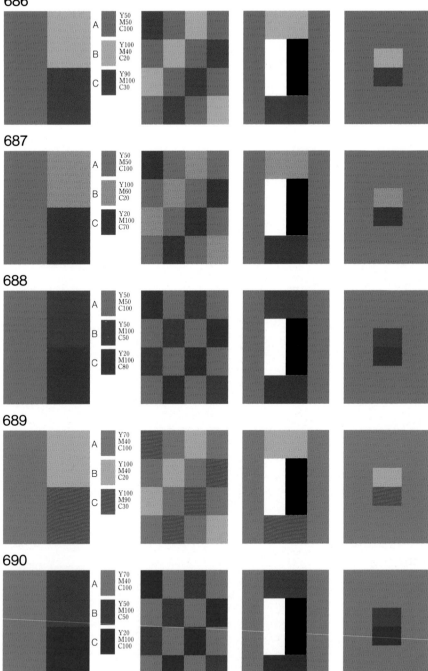

A — Y50 M50 C100
B — Y100 M40 C20
C — Y90 M100 C30

687

A — Y50 M50 C100
B — Y100 M60 C20
C — Y20 M100 C70

688

A — Y50 M50 C100
B — Y50 M100 C50
C — Y20 M100 C80

689

A — Y70 M40 C100
B — Y100 M40 C20
C — Y100 M90 C30

690

A — Y70 M40 C100
B — Y50 M100 C50
C — Y20 M100 C100

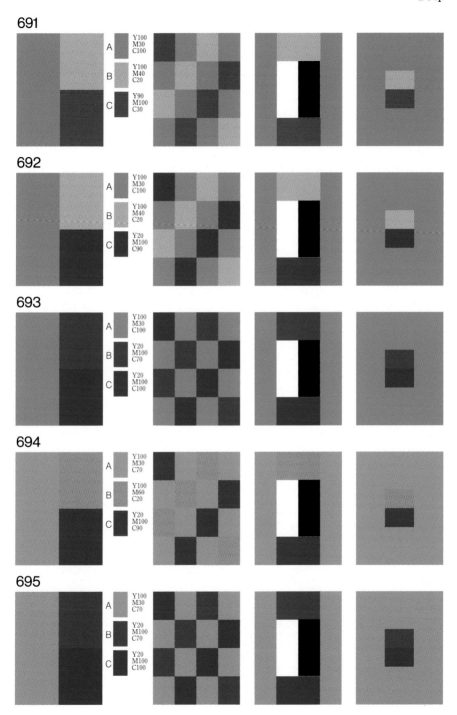

691

A — Y100 M30 C100
B — Y100 M40 C20
C — Y90 M100 C30

692

A — Y100 M30 C100
B — Y100 M40 C20
C — Y20 M100 C90

693

A — Y100 M30 C100
B — Y20 M100 C70
C — Y20 M100 C100

694

A — Y100 M30 C70
B — Y100 M60 C20
C — Y20 M100 C90

695

A — Y100 M30 C70
B — Y20 M100 C70
C — Y20 M100 C100

Deep, 4-color

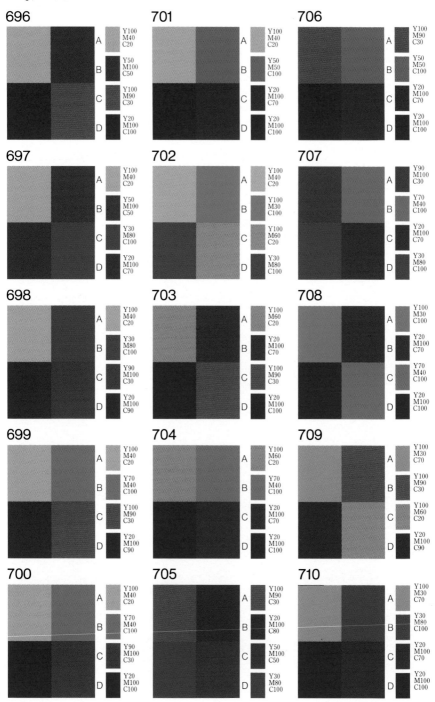

696
- A: Y100 M40 C20
- B: Y50 M100 C50
- C: Y100 M90 C30
- D: Y20 M100 C100

701
- A: Y100 M40 C20
- B: Y50 M50 C100
- C: Y20 M100 C70
- D: Y20 M100 C100

706
- A: Y100 M90 C30
- B: Y50 M50 C100
- C: Y20 M100 C70
- D: Y20 M100 C100

697
- A: Y100 M40 C20
- B: Y50 M100 C50
- C: Y30 M80 C100
- D: Y20 M100 C70

702
- A: Y100 M40 C20
- B: Y100 M30 C100
- C: Y20 M60 C20
- D: Y30 M80 C100

707
- A: Y90 M100 C30
- B: Y70 M40 C100
- C: Y20 M100 C70
- D: Y30 M80 C100

698
- A: Y100 M40 C20
- B: Y30 M80 C100
- C: Y90 M100 C30
- D: Y20 M100 C90

703
- A: Y100 M60 C20
- B: Y20 M100 C70
- C: Y100 M90 C30
- D: Y20 M100 C100

708
- A: Y100 M30 C100
- B: Y20 M100 C70
- C: Y70 M40 C100
- D: Y20 M100 C100

699
- A: Y100 M40 C20
- B: Y70 M40 C100
- C: Y100 M90 C30
- D: Y20 M100 C90

704
- A: Y100 M60 C20
- B: Y70 M40 C100
- C: Y20 M100 C70
- D: Y20 M100 C100

709
- A: Y100 M30 C70
- B: Y100 M90 C30
- C: Y100 M60 C20
- D: Y20 M100 C90

700
- A: Y100 M40 C20
- B: Y70 M40 C100
- C: Y90 M100 C30
- D: Y20 M100 C100

705
- A: Y100 M90 C30
- B: Y20 M100 C80
- C: Y50 M100 C50
- D: Y30 M80 C100

710
- A: Y100 M30 C70
- B: Y30 M80 C100
- C: Y20 M100 C70
- D: Y20 M100 C100

Deep + Dark, 4-color

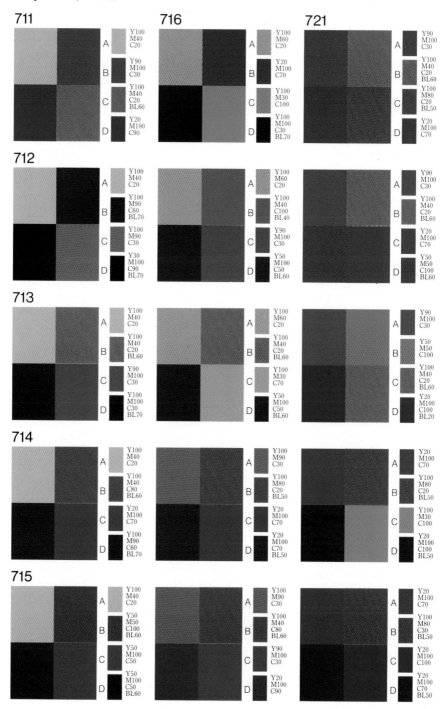

711
- A: Y100 M40 C20
- B: Y90 M100 C30
- C: Y100 M40 C20 BL60
- D: Y20 M100 C90

712
- A: Y100 M40 C20
- B: Y100 M90 C60 BL70
- C: Y100 M90 C30
- D: Y30 M100 C90 BL70

713
- A: Y100 M40 C20
- B: Y100 M40 C20 BL60
- C: Y90 M100 C30
- D: Y100 M100 C30 BL70

714
- A: Y100 M40 C20
- B: Y100 M40 C80 BL60
- C: Y20 M100 C70
- D: Y100 M90 C60 BL70

715
- A: Y100 M40 C20
- B: Y50 M50 C100 BL60
- C: Y50 M100 C50
- D: Y50 M100 C50 BL60

716
- A: Y100 M60 C20
- B: Y20 M100 C70
- C: Y100 M30 C100
- D: Y100 M100 C30 BL70


- A: Y100 M60 C20
- B: Y100 M40 C100 BL40
- C: Y90 M100 C30
- D: Y50 M100 C50 BL60


- A: Y100 M60 C20
- B: Y100 M40 C20 BL60
- C: Y100 M30 C70
- D: Y50 M100 C50 BL60

(row 4)
- A: Y100 M90 C30
- B: Y100 M80 C20 BL50
- C: Y20 M100 C70
- D: Y20 M100 C70 BL50

(row 5)
- A: Y100 M90 C30
- B: Y100 M40 C80 BL60
- C: Y90 M100 C30
- D: Y20 M100 C90

721
- A: Y90 M100 C30
- B: Y100 M40 C20 BL60
- C: Y100 M80 C20 BL50
- D: Y20 M100 C70

(721 - row 2)
- A: Y90 M100 C30
- B: Y100 M40 C20 BL60
- C: Y20 M100 C70
- D: Y50 M50 C100 BL60

(row 3)
- A: Y90 M100 C30
- B: Y50 M50 C100
- C: Y100 M40 C20 BL60
- D: Y100 M100 C100 BL20

(row 4)
- A: Y20 M100 C70
- B: Y100 M80 C20 BL50
- C: Y100 M30 C100
- D: Y100 M100 C100 BL50

(row 5)
- A: Y20 M100 C70
- B: Y100 M80 C30 BL50
- C: Y20 M100 C100
- D: Y20 M100 C70 BL50

Deep + Grayish

| | モザイク | 白・黒 | ポイント |

726

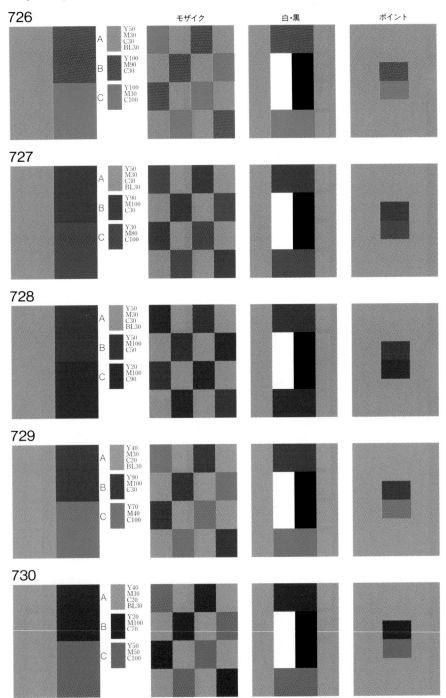

A Y50 M30 C30 BL30
B Y100 M90 C30
C Y100 M30 C100

727

A Y50 M30 C30 BL30
B Y90 M100 C30
C Y30 M80 C100

728

A Y50 M30 C30 BL30
B Y50 M100 C50
C Y20 M100 C90

729

A Y40 M30 C20 BL30
B Y90 M100 C30
C Y70 M40 C100

730

A Y40 M30 C20 BL30
B Y20 M100 C70
C Y50 M50 C100

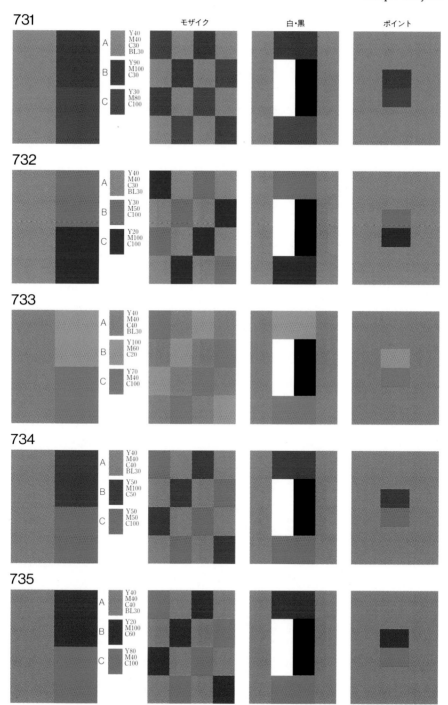

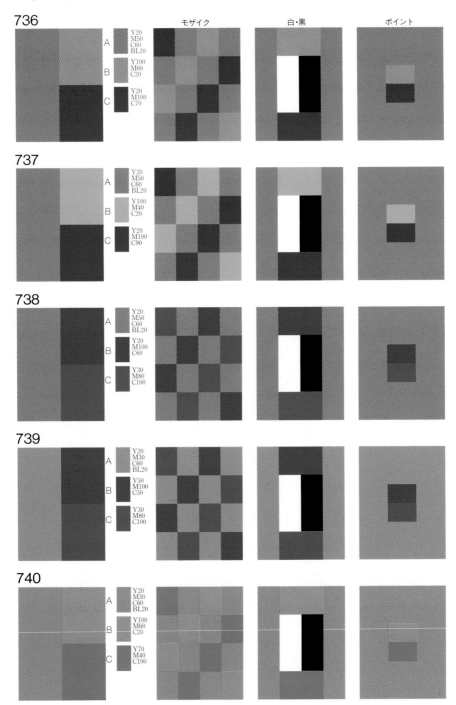

736

A Y20 M50 C60 BL20
B Y100 M60 C20
C Y20 M100 C70

737

A Y20 M50 C60 BL20
B Y100 M40 C20
C Y20 M100 C90

738

A Y20 M50 C60 BL20
B Y20 M100 C60
C Y30 M80 C100

739

A Y20 M30 C60 BL20
B Y50 M100 C50
C Y30 M80 C100

740

A Y20 M30 C60 BL20
B Y100 M60 C20
C Y70 M40 C100

モザイク　白・黒　ポイント

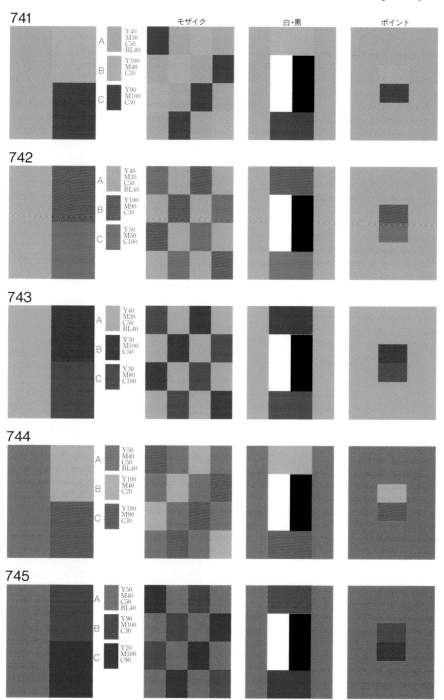

Deep + Grayish

741

A — Y40 M30 C50 BL40
B — Y100 M40 C20
C — Y90 M100 C30

742

A — Y40 M30 C50 BL40
B — Y100 M90 C30
C — Y50 M50 C100

743

A — Y40 M30 C50 BL40
B — Y30 M100 C50
C — Y30 M80 C100

744

A — Y50 M40 C50 BL40
B — Y100 M40 C20
C — Y100 M90 C30

745

A — Y50 M40 C50 BL40
B — Y90 M100 C30
C — Y20 M100 C90

モザイク　　　　白・黒　　　　ポイント

dark
grayish

The group of dark tones consists of deep tones made more highly saturated. Darkening deep tones (as well as lightening them) creates a closer relationship between hues. Therefore, dark tones are frequently used with dull tones and with bright contrasts. Although dark tones are generally harmonious with many other tones, they look especially elegant with neutrals such as beiges and grays. Dark tones can be made by adding black to the density figures of the vivid tones.

Grayish tones are harmonious with many other colors because they are basically neutral. Opposite colors do not cancel out each other, and contrasts between colors are surprisingly clear. Grayish tones are divided into three groups according to brightness. They are derived by adding black to the dull tones. In printing, grays can be made by mixing the three primary colors, but are difficult to maintain accurately because of their subtlety.

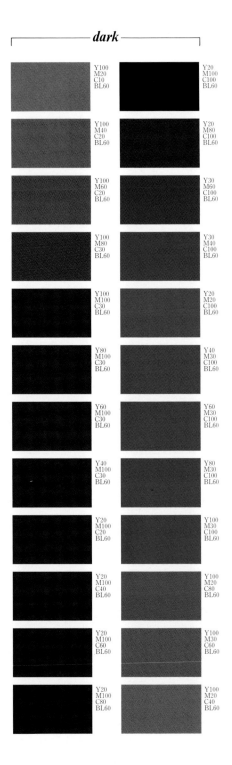

grayish ① grayish ② grayish ③

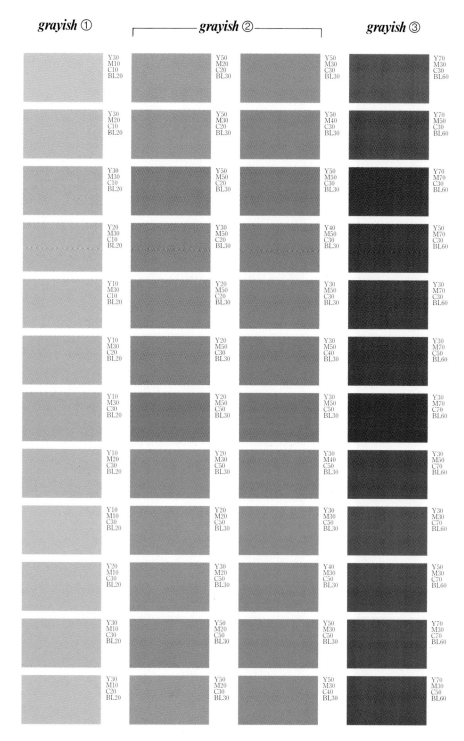

grayish ①	grayish ②	grayish ②	grayish ③
Y30 M10 C10 BL20	Y50 M20 C20 BL30	Y50 M30 C30 BL30	Y70 M30 C30 BL60
Y30 M20 C10 BL20	Y50 M30 C20 BL30	Y50 M40 C30 BL30	Y70 M50 C30 BL60
Y30 M30 C10 BL20	Y50 M50 C20 BL30	Y50 M50 C30 BL30	Y70 M70 C30 BL60
Y20 M30 C10 BL20	Y30 M50 C20 BL30	Y40 M50 C30 BL30	Y50 M70 C30 BL60
Y10 M30 C10 BL20	Y20 M50 C20 BL30	Y30 M50 C30 BL30	Y30 M70 C30 BL60
Y10 M30 C20 BL20	Y20 M50 C30 BL30	Y30 M50 C40 BL30	Y30 M70 C50 BL60
Y10 M30 C30 BL20	Y20 M50 C50 BL30	Y30 M50 C50 BL30	Y30 M70 C70 BL60
Y10 M20 C30 BL20	Y20 M30 C50 BL30	Y30 M40 C50 BL30	Y30 M50 C70 BL60
Y10 M10 C30 BL20	Y20 M20 C50 BL30	Y30 M30 C50 BL30	Y30 M30 C70 BL60
Y20 M10 C30 BL20	Y30 M20 C50 BL30	Y40 M30 C50 BL30	Y50 M30 C70 BL60
Y30 M10 C30 BL20	Y50 M20 C50 BL30	Y50 M30 C50 BL30	Y70 M30 C70 BL60
Y30 M10 C20 BL20	Y50 M20 C30 BL30	Y50 M30 C40 BL30	Y70 M30 C50 BL60

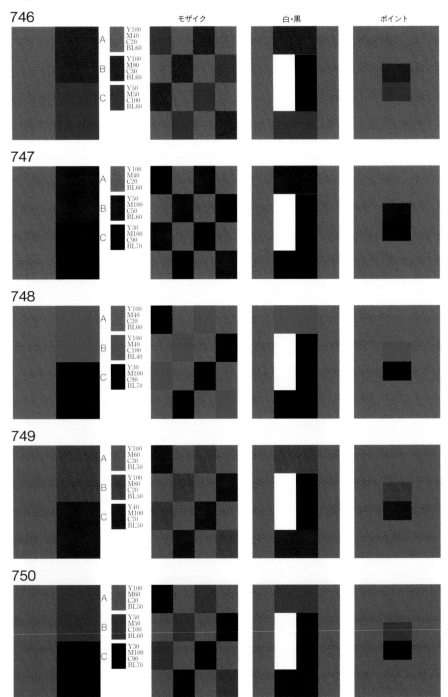

746

A　Y100 M40 C20 BL60
B　Y100 M90 C30 BL60
C　Y50 M50 C100 BL60

747

A　Y100 M40 C20 BL60
B　Y50 M100 C50 BL60
C　Y30 M100 C90 BL70

748

A　Y100 M40 C20 BL60
B　Y100 M40 C100 BL40
C　Y30 M100 C90 BL70

749

A　Y100 M60 C30 BL50
B　Y100 M80 C20 BL50
C　Y40 M100 C70 BL50

750

A　Y100 M60 C30 BL50
B　Y50 M50 C100 BL60
C　Y30 M100 C90 BL70

モザイク　　白・黒　　ポイント

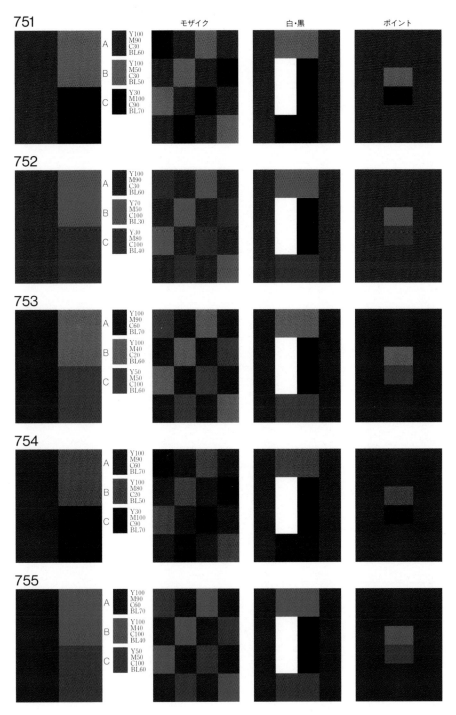

751

モザイク 白・黒 ポイント

A Y100 M90 C30 BL60
B Y100 M50 C30 BL50
C Y30 M100 C90 BL70

752

A Y100 M90 C30 BL60
B Y70 M50 C100 BL30
C Y30 M80 C100 BL40

753

A Y100 M90 C60 BL70
B Y100 M40 C20 BL60
C Y50 M50 C100 BL60

754

A Y100 M90 C60 BL70
B Y100 M80 C20 BL50
C Y30 M100 C90 BL70

755

A Y100 M90 C60 BL70
B Y100 M40 C100 BL40
C Y50 M50 C100 BL60

Dark

756

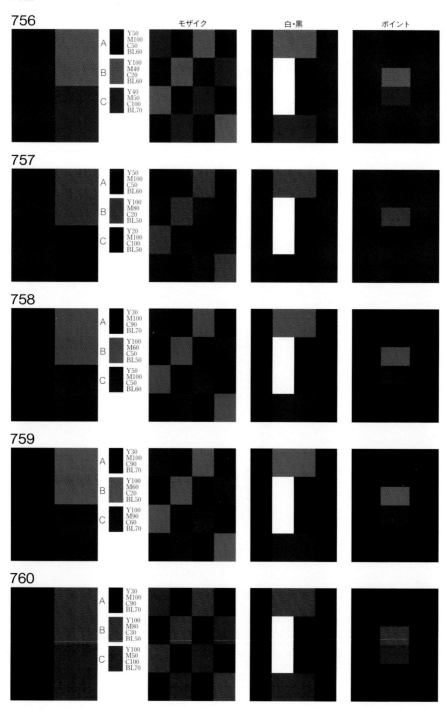

モザイク　　　　　　白・黒　　　　　　ポイント

757

758

759

760

106

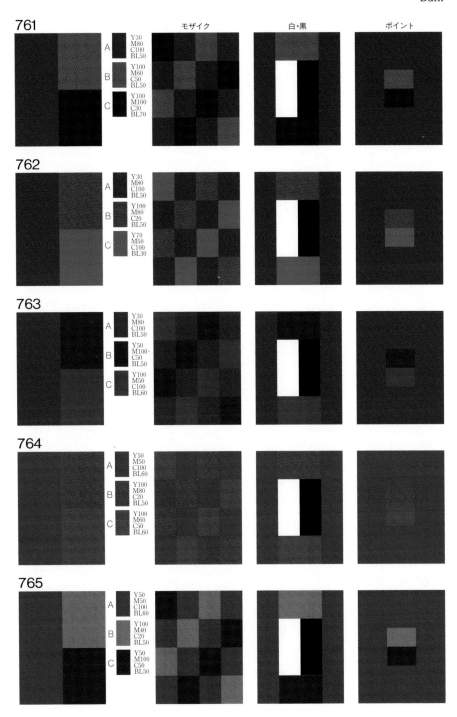

761

モザイク　　　　白・黒　　　　ポイント

A　Y30 M80 C100 BL50
B　Y100 M60 C50 BL50
C　Y100 M100 C30 BL70

762

A　Y30 M80 C100 BL50
B　Y100 M80 C20 BL50
C　Y70 M50 C100 BL30

763

A　Y30 M80 C100 BL50
B　Y50 M100 C50 BL50
C　Y100 M50 C100 BL60

764

A　Y50 M50 C100 BL60
B　Y100 M80 C20 BL50
C　Y100 M60 C50 BL60

765

A　Y50 M50 C100 BL60
B　Y100 M40 C20 BL50
C　Y50 M100 C50 BL50

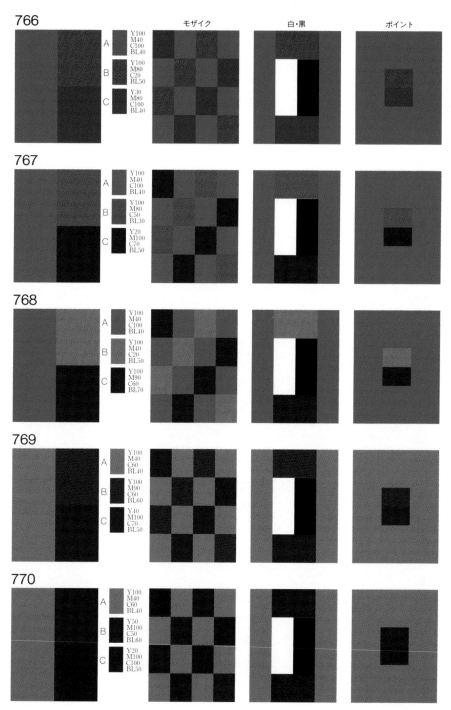

766

A — Y100 M40 C100 BL40
B — Y100 M80 C20 BL50
C — Y30 M80 C100 BL40

767

A — Y100 M40 C100 BL40
B — Y100 M80 C50 BL30
C — Y20 M100 C70 BL50

768

A — Y100 M40 C100 BL40
B — Y100 M40 C20 BL50
C — Y100 M90 C60 BL70

769

A — Y100 M40 C60 BL40
B — Y100 M90 C60 BL60
C — Y40 M100 C70 BL50

770

A — Y100 M40 C60 BL40
B — Y50 M100 C50 BL60
C — Y20 M100 C100 BL50

モザイク　　　　白・黒　　　　ポイント

Dark, 4-color

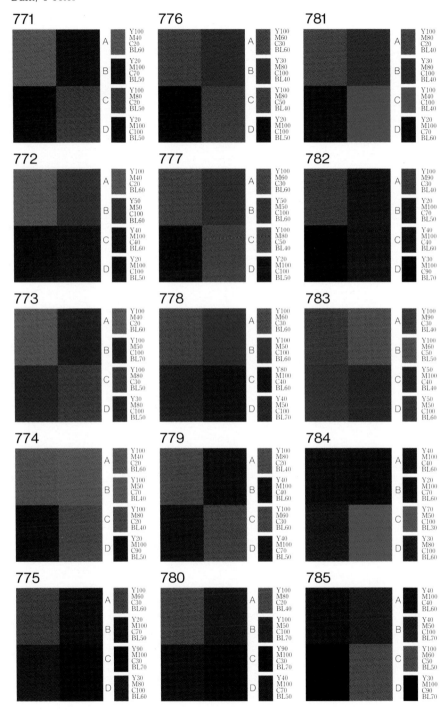

771

A — Y100 M40 C20 BL60
B — Y20 M100 C70 BL50
C — Y100 M80 C20 BL50
D — Y20 M100 C100 BL50

776

A — Y100 M60 C30 BL40
B — Y30 M80 C100 BL40
C — Y100 M80 C50 BL40
D — Y20 M100 C100 BL50

781

A — Y100 M80 C20 BL40
B — Y30 M80 C100 BL40
C — Y100 M40 C100 BL40
D — Y20 M100 C70 BL60

772

A — Y100 M40 C20 BL60
B — Y50 M50 C100 BL60
C — Y40 M100 C40 BL60
D — Y20 M100 C100 BL50

777

A — Y100 M60 C30 BL60
B — Y50 M50 C100 BL60
C — Y100 M80 C50 BL40
D — Y20 M100 C100 BL50

782

A — Y100 M90 C30 BL40
B — Y20 M100 C70 BL50
C — Y40 M100 C40 BL60
D — Y30 M100 C90 BL70

773

A — Y100 M40 C20 BL60
B — Y100 M50 C100 BL70
C — Y100 M80 C30 BL50
D — Y30 M80 C100 BL50

778

A — Y100 M60 C30 BL60
B — Y100 M50 C100 BL60
C — Y80 M100 C40 BL60
D — Y40 M50 C100 BL70

783

A — Y100 M90 C30 BL40
B — Y100 M60 C50 BL50
C — Y50 M100 C40 BL40
D — Y50 M50 C100 BL60

774

A — Y100 M40 C20 BL60
B — Y100 M50 C70 BL40
C — Y100 M80 C20 BL40
D — Y20 M100 C90 BL50

779

A — Y100 M80 C20 BL40
B — Y40 M100 C40 BL60
C — Y100 M60 C30 BL60
D — Y40 M100 C70 BL50

784

A — Y40 M100 C40 BL60
B — Y20 M100 C70 BL60
C — Y70 M50 C100 BL30
D — Y30 M80 C100 BL60

775

A — Y100 M60 C30 BL60
B — Y20 M100 C70 BL50
C — Y90 M100 C30 BL70
D — Y30 M80 C100 BL60

780

A — Y100 M80 C20 BL40
B — Y100 M50 C100 BL70
C — Y90 M100 C30 BL70
D — Y40 M100 C70 BL50

785

A — Y40 M100 C40 BL60
B — Y40 M50 C100 BL70
C — Y100 M60 C50 BL50
D — Y30 M100 C90 BL70

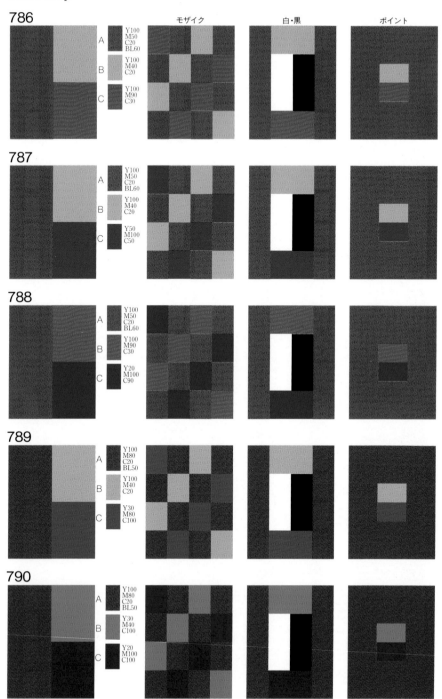

786

A	Y100 M50 C20 BL60
B	Y100 M40 C20
C	Y100 M90 C30

787

A	Y100 M50 C20 BL60
B	Y100 M40 C20
C	Y50 M100 C50

788

A	Y100 M50 C20 BL60
B	Y100 M90 C30
C	Y20 M100 C90

789

A	Y100 M80 C20 BL50
B	Y100 M40 C20
C	Y30 M80 C100

790

A	Y100 M80 C20 BL50
B	Y30 M40 C100
C	Y20 M100 C100

モザイク　　　白・黒　　　ポイント

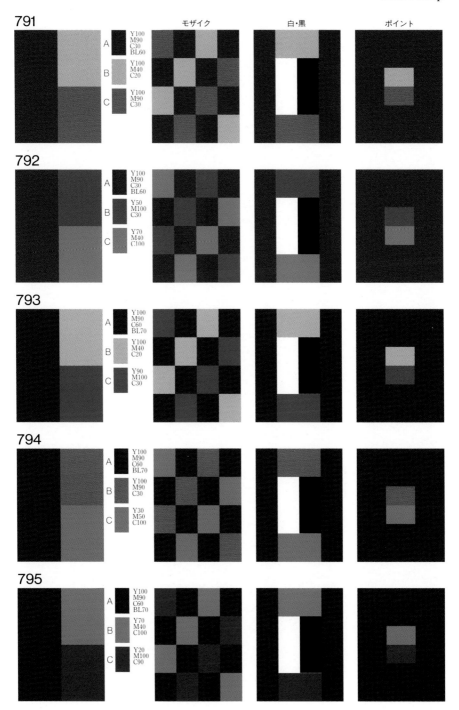

791

A Y100 M90 C30 BL60
B Y100 M40 C20
C Y100 M90 C30

モザイク　白・黒　ポイント

792

A Y100 M90 C30 BL60
B Y50 M100 C30
C Y70 M40 C100

793

A Y100 M90 C60 BL70
B Y100 M40 C20
C Y90 M100 C30

794

A Y100 M90 C60 BL70
B Y100 M90 C30
C Y30 M50 C100

795

A Y100 M90 C60 BL70
B Y70 M40 C100
C Y20 M100 C90

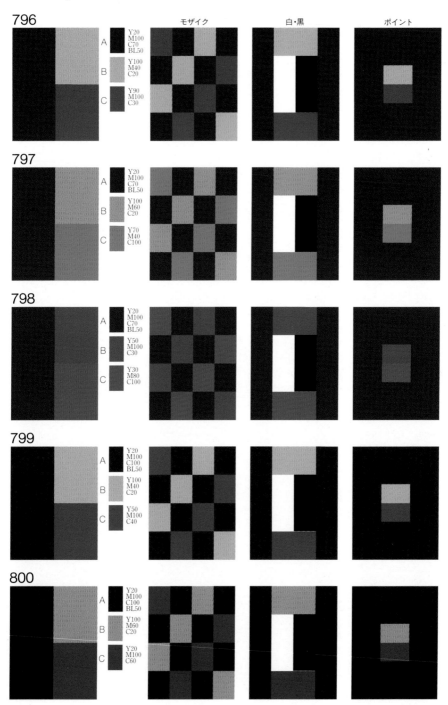

モザイク　　　　　白・黒　　　　　ポイント

796

A Y20 M100 C70 BL50
B Y100 M40 C20
C Y90 M100 C30

797

A Y20 M100 C70 BL50
B Y100 M60 C20
C Y70 M40 C100

798

A Y20 M100 C70 BL50
B Y50 M100 C30
C Y30 M80 C100

799

A Y20 M100 C100 BL50
B Y100 M40 C20
C Y50 M100 C40

800

A Y20 M100 C100 BL50
B Y100 M60 C20
C Y20 M100 C60

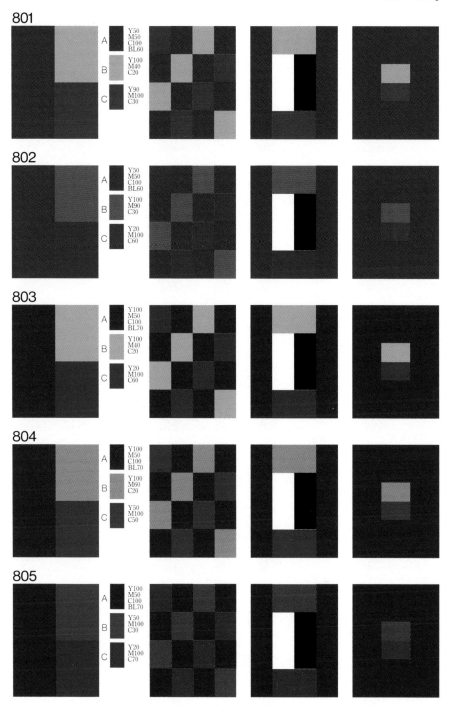

801
A Y50 M50 C100 BL60
B Y100 M40 C20
C Y90 M100 C30

802
A Y50 M50 C100 BL60
B Y100 M90 C30
C Y20 M100 C60

803
A Y100 M50 C100 BL70
B Y100 M40 C20
C Y20 M100 C60

804
A Y100 M50 C100 BL70
B Y100 M60 C20
C Y50 M100 C50

805
A Y100 M50 C100 BL70
B Y50 M100 C30
C Y20 M100 C70

806

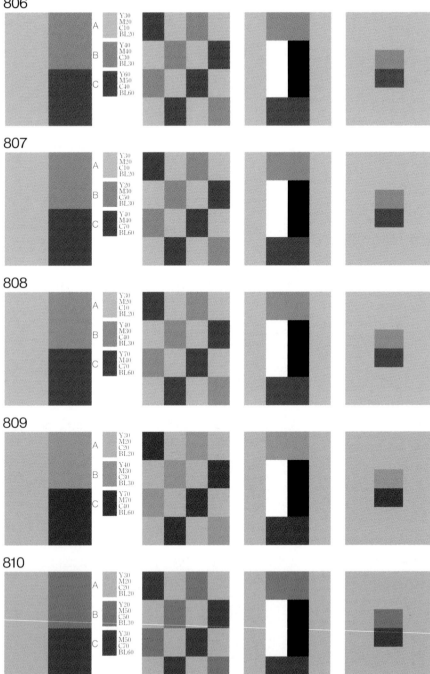

A	Y30 M20 C10 BL20
B	Y40 M40 C30 BL30
C	Y60 M50 C40 BL60

807

A	Y30 M20 C10 BL20
B	Y20 M30 C50 BL30
C	Y40 M40 C70 BL60

808

A	Y30 M20 C10 BL20
B	Y40 M30 C40 BL30
C	Y70 M40 C70 BL60

809

A	Y30 M20 C20 BL20
B	Y40 M30 C30 BL30
C	Y70 M70 C40 BL60

810

A	Y30 M20 C20 BL20
B	Y20 M50 C50 BL30
C	Y30 M50 C70 BL60

811

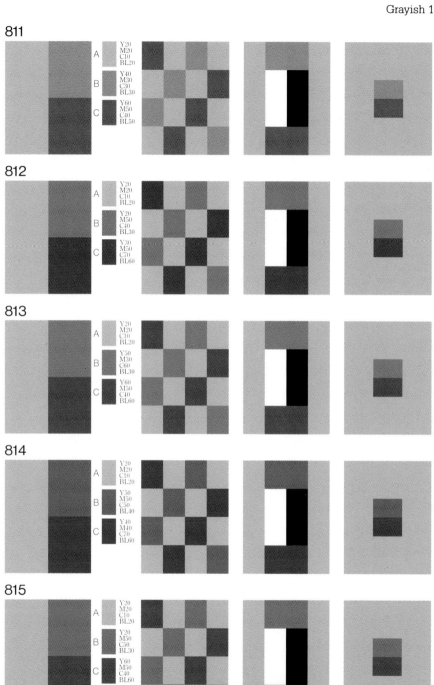

A Y20 M20 C10 BL20
B Y40 M30 C30 BL30
C Y60 M50 C40 BL50

812

A Y20 M20 C10 BL20
B Y20 M50 C40 BL30
C Y30 M50 C70 BL60

813

A Y20 M20 C10 BL20
B Y50 M30 C60 BL30
C Y60 M50 C40 BL60

814

A Y20 M20 C10 BL20
B Y50 M50 C50 BL40
C Y40 M40 C70 BL60

815

A Y20 M20 C10 BL20
B Y20 M50 C50 BL30
C Y60 M50 C40 BL60

816

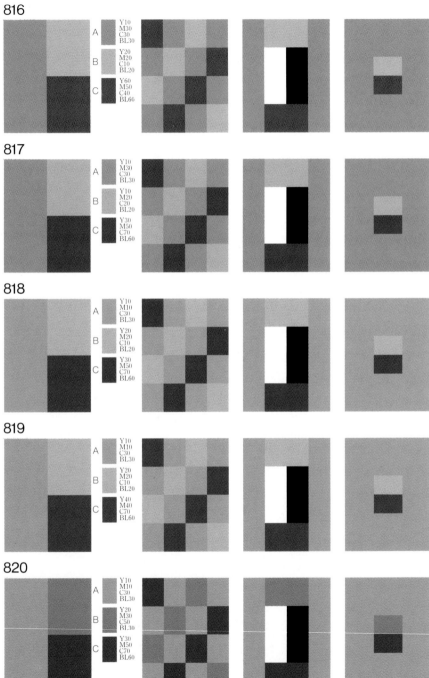

A
Y10
M30
C30
BL30

B
Y20
M20
C10
BL20

C
Y60
M50
C40
BL60

817

A
Y10
M30
C30
BL30

B
Y10
M20
C20
BL20

C
Y30
M50
C70
BL60

818

A
Y10
M10
C30
BL30

B
Y20
M20
C10
BL20

C
Y30
M50
C70
BL60

819

A
Y10
M10
C30
BL30

B
Y20
M20
C10
BL20

C
Y40
M40
C70
BL60

820

A
Y10
M10
C30
BL30

B
Y20
M30
C50
BL30

C
Y30
M50
C70
BL60

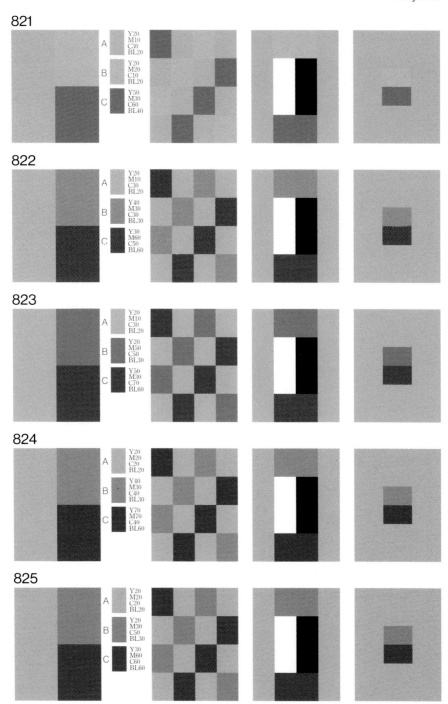

821

A — Y20 M10 C30 BL20
B — Y20 M20 C10 BL20
C — Y50 M30 C60 BL40

822

A — Y20 M10 C30 BL20
B — Y40 M30 C30 BL30
C — Y30 M60 C50 BL60

823

A — Y20 M10 C30 BL20
B — Y20 M50 C50 BL30
C — Y50 M30 C70 BL60

824

A — Y20 M20 C20 BL20
B — Y40 M30 C40 BL30
C — Y70 M70 C40 BL60

825

A — Y20 M20 C20 BL20
B — Y20 M30 C50 BL30
C — Y30 M60 C60 BL60

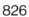

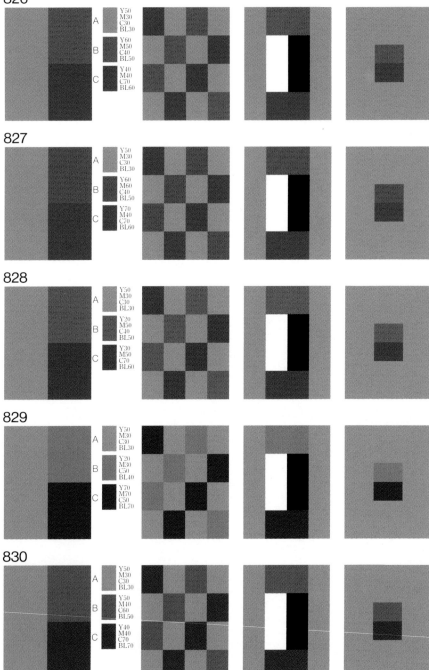

826

A Y50 M30 C30 BL30
B Y60 M50 C40 BL50
C Y40 M40 C70 BL60

827

A Y50 M30 C30 BL30
B Y60 M60 C40 BL50
C Y70 M40 C70 BL60

828

A Y50 M30 C30 BL30
B Y20 M50 C40 BL50
C Y30 M50 C70 BL60

829

A Y50 M30 C30 BL30
B Y20 M30 C50 BL40
C Y70 M70 C50 BL70

830

A Y50 M30 C30 BL30
B Y50 M40 C60 BL50
C Y40 M40 C70 BL70

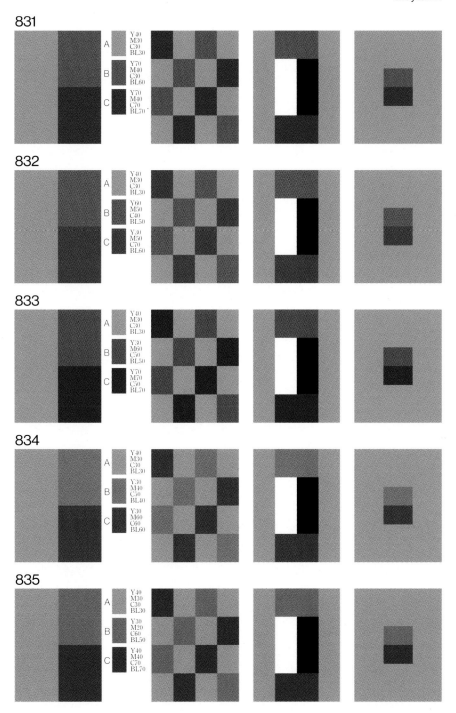

831

A
Y40
M30
C30
BL30

B
Y70
M40
C30
BL60

C
Y70
M40
C70
BL70

832

A
Y40
M30
C30
BL30

B
Y60
M50
C40
BL50

C
Y30
M50
C70
BL60

833

A
Y40
M30
C30
BL30

B
Y30
M60
C50
BL50

C
Y70
M70
C50
BL70

834

A
Y40
M30
C30
BL30

B
Y30
M40
C50
BL40

C
Y30
M60
C60
BL60

835

A
Y40
M30
C30
BL30

B
Y30
M20
C60
BL50

C
Y40
M40
C70
BL70

Grayish 2

836

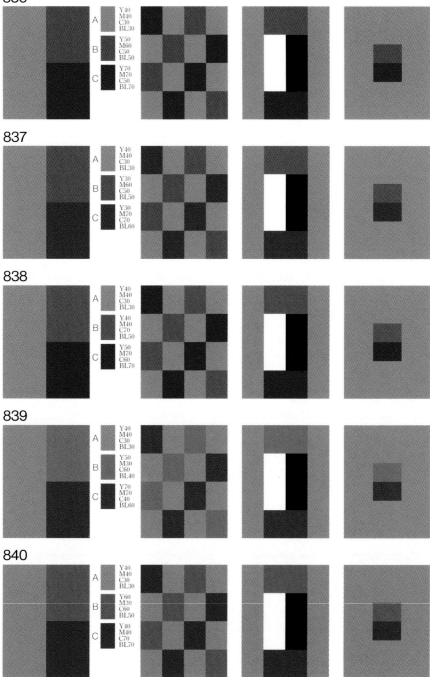

A — Y40 M40 C30 BL30
B — Y50 M60 C50 BL50
C — Y70 M70 C50 BL70

837

A — Y40 M40 C30 BL30
B — Y30 M60 C50 BL50
C — Y30 M70 C70 BL60

838

A — Y40 M40 C30 BL30
B — Y40 M40 C70 BL50
C — Y50 M70 C60 BL70

839

A — Y40 M40 C30 BL30
B — Y50 M30 C60 BL40
C — Y70 M70 C40 BL60

840

A — Y40 M40 C30 BL30
B — Y60 M30 C60 BL50
C — Y40 M40 C70 BL70

120

841

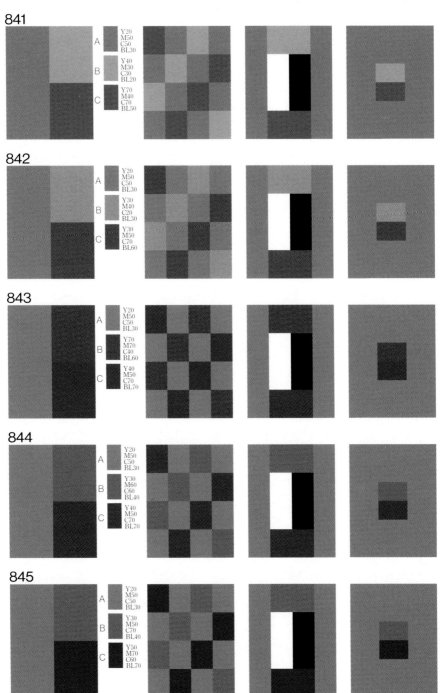

A
Y20
M50
C50
BL30

B
Y40
M30
C30
BL20

C
Y70
M40
C70
BL50

842

A
Y20
M50
C50
BL30

B
Y30
M40
C20
BL30

C
Y30
M50
C70
BL60

843

A
Y20
M50
C50
BL30

B
Y70
M70
C40
BL60

C
Y40
M50
C70
BL70

844

A
Y20
M50
C50
BL30

B
Y30
M60
C60
BL40

C
Y40
M50
C70
BL70

845

A
Y20
M50
C50
BL30

B
Y30
M50
C70
BL40

C
Y50
M70
C60
BL70

Grayish 2

846

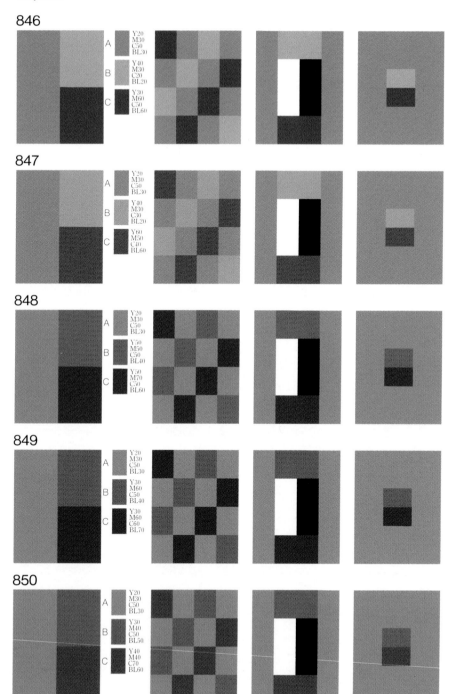

A — Y20 M30 C50 BL30
B — Y40 M30 C20 BL20
C — Y30 M60 C50 BL60

847

A — Y20 M30 C50 BL30
B — Y40 M30 C30 BL20
C — Y60 M50 C10 BL60

848

A — Y20 M30 C50 BL30
B — Y50 M50 C50 BL40
C — Y50 M70 C50 BL60

849

A — Y20 M30 C50 BL30
B — Y30 M60 C50 BL40
C — Y30 M60 C60 BL70

850

A — Y20 M30 C50 BL30
B — Y30 M40 C50 BL50
C — Y40 M40 C70 BL60

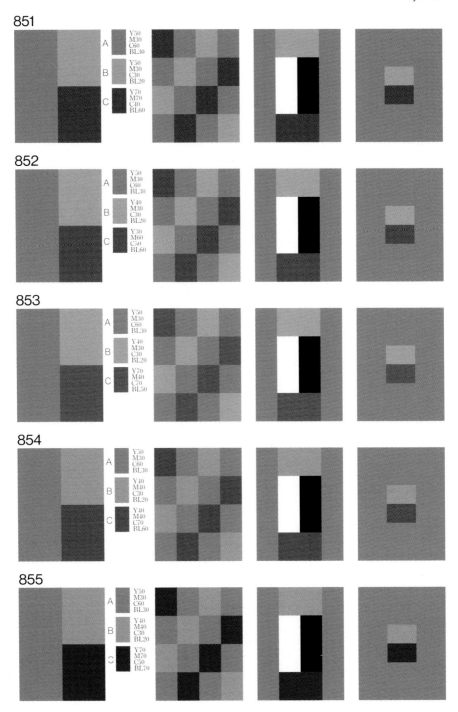

851

A Y50 M30 C60 BL30
B Y50 M30 C30 BL20
C Y70 M70 C40 BL60

852

A Y50 M30 C60 BL30
B Y40 M30 C30 BL20
C Y30 M60 C50 BL60

853

A Y50 M30 C60 BL30
B Y40 M30 C30 BL20
C Y70 M40 C70 BL50

854

A Y50 M30 C60 BL30
B Y40 M40 C30 BL20
C Y40 M40 C70 BL60

855

A Y50 M30 C60 BL30
B Y10 M40 C30 BL20
C Y70 M70 C50 BL70

Grayish 3

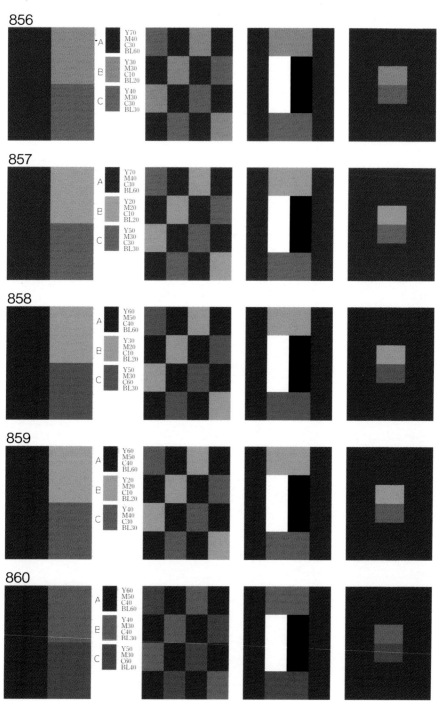

856

A — Y70 M40 C30 BL60
B — Y30 M30 C10 BL20
C — Y40 M30 C30 BL30

857

A — Y70 M40 C30 BL60
B — Y20 M20 C10 BL20
C — Y50 M30 C30 BL30

858

A — Y60 M50 C40 BL60
B — Y30 M20 C10 BL20
C — Y50 M30 C60 BL30

859

A — Y60 M50 C40 BL60
B — Y20 M20 C10 BL20
C — Y40 M40 C30 BL30

860

A — Y60 M50 C40 BL60
B — Y40 M30 C40 BL30
C — Y50 M30 C60 BL40

861

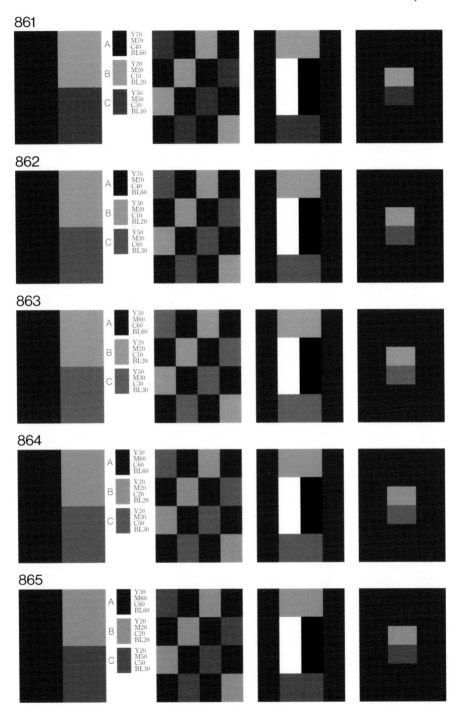

A		Y70 M70 C40 BL60
B		Y20 M20 C10 BL20
C		Y50 M50 C50 BL40

862

A		Y70 M70 C40 BL60
B		Y30 M20 C10 BL20
C		Y50 M30 C60 BL30

863

A		Y30 M60 C60 BL60
B		Y20 M20 C10 BL20
C		Y50 M30 C30 BL30

864

A		Y30 M60 C60 BL60
B		Y20 M20 C20 BL20
C		Y20 M30 C50 BL30

865

A		Y30 M60 C60 BL60
B		Y20 M20 C20 BL20
C		Y20 M50 C50 BL30

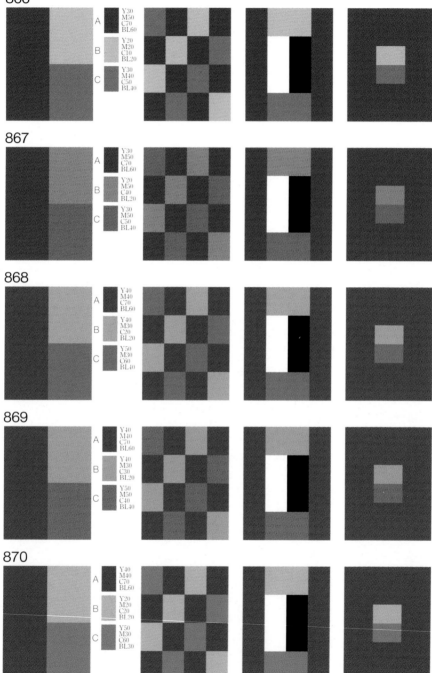

866

A Y30 M50 C70 BL60
B Y20 M20 C10 BL20
C Y30 M40 C50 BL40

867

A Y30 M50 C70 BL60
B Y20 M50 C40 BL20
C Y30 M50 C50 BL40

868

A Y40 M40 C70 BL60
B Y40 M30 C20 BL20
C Y50 M30 C60 BL40

869

A Y40 M40 C70 BL60
B Y40 M30 C30 BL20
C Y50 M50 C40 BL40

870

A Y40 M40 C70 BL60
B Y20 M20 C20 BL20
C Y50 M30 C60 BL30

871

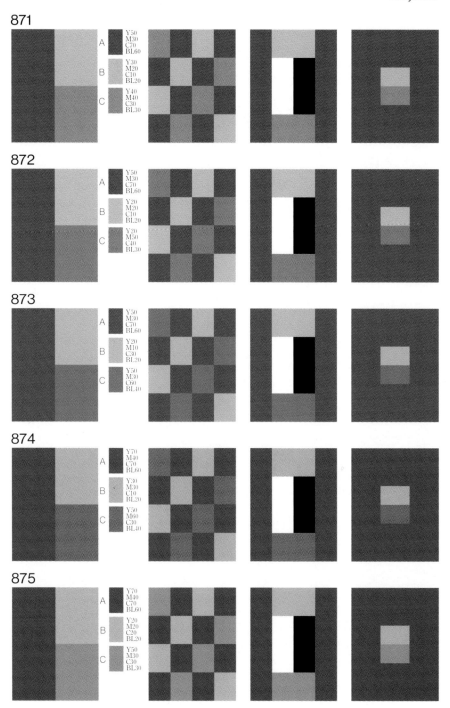

872

873

874

875

871
A — Y50 M30 C70 BL60
B — Y30 M20 C10 BL20
C — Y40 M40 C30 BL30

872
A — Y50 M30 C70 BL60
B — Y20 M20 C10 BL20
C — Y20 M50 C40 BL30

873
A — Y50 M30 C70 BL60
B — Y20 M10 C30 BL20
C — Y50 M30 C60 BL40

874
A — Y70 M40 C70 BL60
B — Y30 M30 C10 BL20
C — Y50 M60 C30 BL40

875
A — Y70 M40 C70 BL60
B — Y20 M20 C20 BL20
C — Y50 M30 C30 BL30

Grayish, 4-color 1

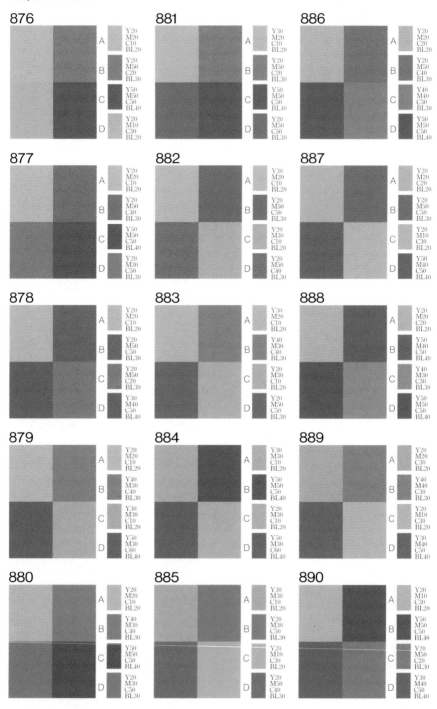

876
A Y20 M20 C10 BL20
B Y20 M50 C20 BL30
C Y50 M50 C50 BL40
D Y20 M10 C30 BL20

881
A Y30 M20 C10 BL20
B Y20 M50 C20 BL30
C Y50 M50 C50 BL40
D Y20 M50 C50 BL30

886
A Y20 M20 C20 BL20
B Y20 M50 C40 BL30
C Y40 M40 C30 BL30
D Y50 M50 C50 BL40

877
A Y20 M20 C10 BL20
B Y20 M50 C40 BL30
C Y50 M50 C50 BL40
D Y20 M30 C50 BL30

882
A Y30 M20 C10 BL20
B Y20 M50 C50 BL30
C Y20 M30 C10 BL20
D Y20 M50 C40 BL30

887
A Y20 M20 C20 BL20
B Y20 M50 C50 BL30
C Y20 M10 C30 BL20
D Y50 M40 C50 BL40

878
A Y20 M20 C10 BL20
B Y20 M50 C50 BL30
C Y20 M50 C20 BL30
D Y30 M40 C50 BL40

883
A Y30 M20 C10 BL20
B Y40 M30 C40 BL30
C Y20 M30 C10 BL20
D Y20 M50 C50 BL30

888
A Y20 M20 C20 BL20
B Y50 M40 C50 BL40
C Y40 M30 C30 BL30
D Y20 M50 C50 BL40

879
A Y20 M20 C10 BL20
B Y40 M30 C40 BL30
C Y30 M30 C10 BL20
D Y50 M30 C60 BL40

884
A Y30 M30 C10 BL20
B Y50 M50 C50 BL40
C Y20 M30 C10 BL20
D Y50 M30 C60 BL40

889
A Y20 M20 C30 BL20
B Y40 M40 C30 BL30
C Y20 M10 C30 BL20
D Y30 M40 C50 BL40

880
A Y20 M20 C10 BL20
B Y40 M30 C40 BL30
C Y50 M50 C50 BL40
D Y20 M30 C50 BL30

885
A Y30 M30 C10 BL20
B Y20 M30 C50 BL30
C Y20 M10 C30 BL20
D Y20 M50 C40 BL30

890
A Y20 M10 C30 BL20
B Y50 M50 C50 BL40
C Y20 M50 C20 BL30
D Y30 M40 C50 BL40

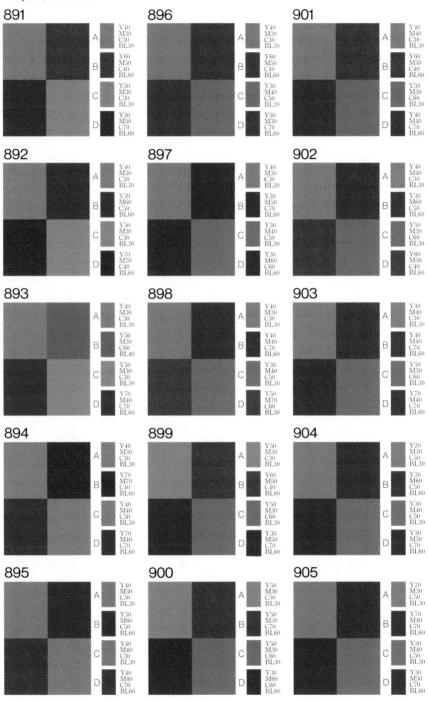

891
A — Y40 M30 C30 BL30
B — Y60 M50 C40 BL60
C — Y50 M30 C30 BL30
D — Y30 M50 C70 BL60

896
A — Y40 M30 C30 BL30
B — Y60 M50 C40 BL60
C — Y50 M40 C50 BL30
D — Y50 M30 C70 BL60

901
A — Y40 M30 C30 BL30
B — Y60 M50 C40 BL60
C — Y50 M30 C60 BL30
D — Y50 M40 C70 BL60

892
A — Y40 M30 C30 BL30
B — Y30 M60 C50 BL60
C — Y50 M30 C30 BL30
D — Y70 M70 C40 BL60

897
A — Y40 M30 C30 BL30
B — Y30 M50 C70 BL60
C — Y50 M40 C50 BL30
D — Y30 M60 C60 BL60

902
A — Y40 M40 C30 BL30
B — Y30 M60 C50 BL30
C — Y50 M30 C60 BL30
D — Y60 M50 C40 BL60

893
A — Y40 M30 C30 BL30
B — Y50 M30 C60 BL40
C — Y50 M30 C30 BL30
D — Y70 M40 C70 BL60

898
A — Y40 M30 C30 BL30
B — Y40 M40 C70 BL60
C — Y30 M40 C50 BL30
D — Y50 M70 C60 BL30

903
A — Y40 M40 C30 BL30
B — Y40 M40 C70 BL60
C — Y50 M30 C60 BL30
D — Y70 M40 C70 BL60

894
A — Y40 M30 C30 BL30
B — Y70 M70 C40 BL60
C — Y40 M40 C30 BL30
D — Y70 M40 C70 BL60

899
A — Y50 M30 C30 BL30
B — Y60 M50 C40 BL60
C — Y50 M30 C60 BL30
D — Y50 M50 C70 BL60

904
A — Y20 M30 C50 BL30
B — Y30 M60 C50 BL60
C — Y30 M40 C50 BL30
D — Y30 M50 C70 BL60

895
A — Y40 M30 C30 BL30
B — Y30 M60 C50 BL60
C — Y40 M40 C30 BL30
D — Y40 M40 C70 BL60

900
A — Y50 M30 C30 BL30
B — Y50 M30 C70 BL60
C — Y50 M30 C60 BL30
D — Y30 M60 C60 BL60

905
A — Y20 M30 C50 BL30
B — Y70 M40 C70 BL60
C — Y30 M40 C50 BL30
D — Y30 M50 C70 BL60

Appendix 1 Black and White Type Chart

pale		light	bright

Y20 — Color Color | Y30 — Color Color | Y50 — Color Color | Y70 — Color Color

Y20 M10 — Color Color | Y30 M10 — Color Color | Y50 M30 — Color Color | Y70 M40 — Color Color

Y20 M20 — Color Color | Y30 M30 — Color Color | Y50 M50 — Color Color | Y70 M70 — Color Color

Y10 M20 — Color Color | Y10 M30 — Color Color | Y30 M50 — Color Color | Y40 M70 — Color Color

M20 — Color Color | M30 — Color Color | M50 — Color Color | M70 — Color Color

M20 C10 — Color Color | M30 C10 — Color Color | M50 C30 — Color Color | M70 C40 — Color Color

M20 C20 — Color Color | M30 C30 — Color Color | M50 C50 — Color Color | M70 C70 — Color Color

M10 C20 — Color Color | M10 C30 — Color Color | M30 C50 — Color Color | M40 C70 — Color Color

C20 — Color Color | C30 — Color Color | C50 — Color Color | C70 — Color Color

Y10 C20 — Color Color | Y10 C30 — Color Color | Y30 C50 — Color Color | Y40 C70 — Color Color

Y20 C20 — Color Color | Y30 C30 — Color Color | Y50 C50 — Color Color | Y70 C70 — Color Color

Y20 C10 — Color Color | Y30 C10 — Color Color | Y50 C30 — Color Color | Y70 C40 — Color Color

Color Color Y20 M10 C10 Color Color	Color Color Y10 M30 C30 Color Color	Color Color Y50 M20 C20 Color Color	Color Color Y70 M30 C30 Color Color
Color Color Y20 M20 C10 Color Color	Color Color Y10 M20 C30 Color Color	Color Color Y50 M30 C20 Color Color	Color Color Y70 M50 C30 Color Color
Color Color Y10 M20 C10 Color Color	Color Color Y10 M10 C30 Color Color	Color Color Y50 M50 C20 Color Color	Color Color Y70 M70 C30 Color Color
Color Color Y10 M20 C20 Color Color	Color Color Y20 M10 C30 Color Color	Color Color Y30 M50 C20 Color Color	Color Color Y50 M70 C30 Color Color
Color Color Y10 M10 C20 Color Color	Color Color Y30 M10 C30 Color Color	Color Color Y20 M50 C20 Color Color	Color Color Y30 M70 C30 Color Color
Color Color Y20 M10 C20 Color Color	Color Color Y30 M10 C20 Color Color	Color Color Y50 M50 C30 Color Color	Color Color Y30 M70 C50 Color Color
Color Color Y30 M10 C10 Color Color	Color Color Y30 M20 C20 Color Color	Color Color Y20 M50 C50 Color Color	Color Color Y30 M70 C70 Color Color
Color Color Y30 M20 C10 Color Color	Color Color Y30 M30 C20 Color Color	Color Color Y20 M30 C50 Color Color	Color Color Y30 M50 C70 Color Color
Color Color Y30 M30 C10 Color Color	Color Color Y20 M30 C20 Color Color	Color Color Y20 M20 C50 Color Color	Color Color Y30 M30 C70 Color Color
Color Color Y20 M30 C10 Color Color	Color Color Y20 M30 C30 Color Color	Color Color Y30 M20 C50 Color Color	Color Color Y50 M30 C70 Color Color
Color Color Y10 M30 C10 Color Color	Color Color Y20 M20 C30 Color Color	Color Color Y50 M20 C50 Color Color	Color Color Y70 M30 C70 Color Color
Color Color Y10 M30 C20 Color Color	Color Color Y30 M20 C30 Color Color	Color Color Y50 M20 C30 Color Color	Color Color Y70 M30 C50 Color Color

131

vivid — *deep*

	vivid		deep	
Y100	M100 C100	Y100 M20 C20	Y20 M100 C100	
Y100 M30	M70 C100	Y100 M40 C20	Y20 M80 C100	
Y100 M50	M50 C100	Y100 M60 C20	Y20 M60 C100	
Y100 M70	M30 C100	Y100 M80 C20	Y20 M40 C100	
Y100 M100	C100	Y100 M100 C20	Y20 M20 C100	
Y70 M100	Y30 C100	Y80 M100 C20	Y40 M20 C100	
Y50 M100	Y50 C100	Y60 M100 C20	Y60 M20 C100	
Y30 M100	Y70 C100	Y40 M100 C20	Y80 M20 C100	
M100	Y100 C100	Y20 M100 C20	Y100 M20 C100	
M100 C30	Y100 C70	Y20 M100 C40	Y100 M20 C80	
M100 C50	Y100 C50	Y20 M100 C60	Y100 M20 C60	
M100 C70	Y100 C30	Y20 M100 C80	Y100 M20 C40	

Color Color (repeated in each swatch)

132

Color Color Color Color	Y100 M20 C20 BL60	Color Color Color Color	Y30 M10 C10 BL20	Color Color Color Color	Y50 M20 C20 BL30	Color Color Color Color	Y70 M30 C30 BL60
Color Color Color Color	Y100 M60 C20 BL60	Color Color Color Color	Y30 M20 C10 BL20	Color Color Color Color	Y50 M30 C20 BL30	Color Color Color Color	Y70 M50 C30 BL60
Color Color Color Color	Y100 M100 C20 BL60	Color Color Color Color	Y30 M30 C10 BL20	Color Color Color Color	Y50 M50 C20 BL30	Color Color Color Color	Y70 M70 C30 BL60
Color Color Color Color	Y60 M100 C20 BL60	Color Color Color Color	Y20 M30 C10 BL20	Color Color Color Color	Y30 M50 C20 BL30	Color Color Color Color	Y50 M70 C30 BL60
Color Color Color Color	Y20 M100 C20 BL60	Color Color Color Color	Y10 M30 C10 BL20	Color Color Color Color	Y20 M50 C20 BL30	Color Color Color Color	Y30 M70 C30 BL60
Color Color Color Color	Y20 M100 C60 BL60	Color Color Color Color	Y10 M30 C20 BL20	Color Color Color Color	Y20 M50 C30 BL30	Color Color Color Color	Y30 M70 C50 BL60
Color Color Color Color	Y20 M100 C100 BL60	Color Color Color Color	Y10 M30 C30 BL20	Color Color Color Color	Y20 M50 C50 BL30	Color Color Color Color	Y30 M70 C70 BL60
Color Color Color Color	Y20 M60 C100 BL60	Color Color Color Color	Y10 M20 C30 BL20	Color Color Color Color	Y20 M30 C50 BL30	Color Color Color Color	Y30 M50 C70 BL60
Color Color Color Color	Y20 M20 C100 BL60	Color Color Color Color	Y10 M10 C30 BL20	Color Color Color Color	Y20 M20 C50 BL30	Color Color Color Color	Y30 M30 C70 BL60
Color Color Color Color	Y60 M20 C100 BL60	Color Color Color Color	Y20 M10 C30 BL20	Color Color Color Color	Y30 M20 C50 BL30	Color Color Color Color	Y50 M30 C70 BL60
Color Color Color Color	Y100 M20 C100 BL60	Color Color Color Color	Y30 M10 C30 BL20	Color Color Color Color	Y50 M20 C50 BL30	Color Color Color Color	Y70 M30 C70 BL60
Color Color Color Color	Y100 M20 C60 BL60	Color Color Color Color	Y30 M10 C20 BL20	Color Color Color Color	Y50 M20 C30 BL30	Color Color Color Color	Y70 M30 C50 BL60

Appendix 2 Gradation Scales

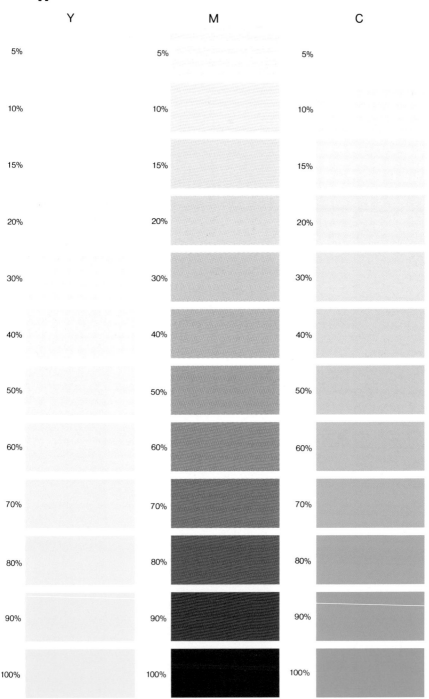

Y	M	C
5%	5%	5%
10%	10%	10%
15%	15%	15%
20%	20%	20%
30%	30%	30%
40%	40%	40%
50%	50%	50%
60%	60%	60%
70%	70%	70%
80%	80%	80%
90%	90%	90%
100%	100%	100%

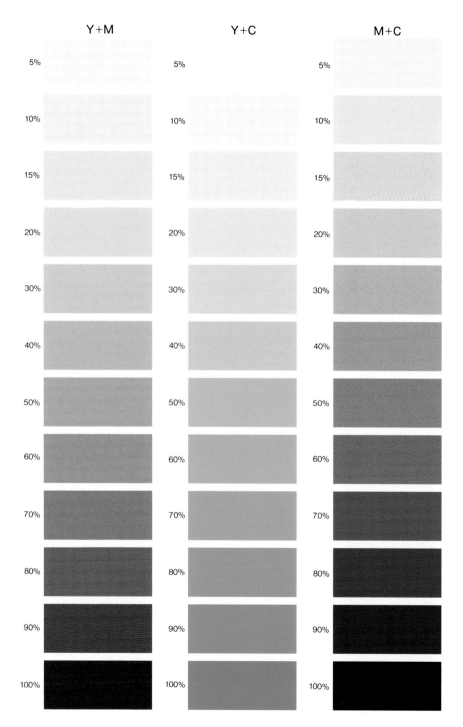

Y+M	Y+C	M+C
5%	5%	5%
10%	10%	10%
15%	15%	15%
20%	20%	20%
30%	30%	30%
40%	40%	40%
50%	50%	50%
60%	60%	60%
70%	70%	70%
80%	80%	80%
90%	90%	90%
100%	100%	100%

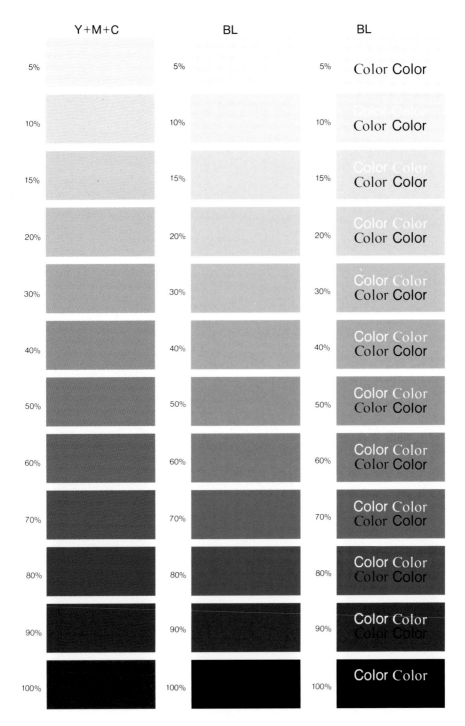

Y+M+C	BL	BL
5%	5%	5% Color Color
10%	10%	10% Color Color
15%	15%	15% Color Color
20%	20%	20% Color Color
30%	30%	30% Color Color
40%	40%	40% Color Color
50%	50%	50% Color Color
60%	60%	60% Color Color
70%	70%	70% Color Color
80%	80%	80% Color Color
90%	90%	90% Color Color
100%	100%	100% Color Color

Appendix 3 Fluorescent Color Chart (Ink is Moroboshi fluorescent ink.)
Printing order: C--> M--> Y

	Y	M	C	Y+M	Y+C	M+C
5%						
10%						
15%						
20%						
30%						
40%						
50%						
60%						
70%						
80%						
90%						
100%						

Fluorescent Color (Magenta) + Process Color (Yellow and Cyan) Chart

pale *light* *bright* *vivid*

pale	light	bright	vivid
Y30	Y50	Y70	Y100
Y30 M10	Y50 M30	Y70 M40	Y100 M50
Y30 M30	Y50 M50	Y70 M70	Y100 M100
Y10 M30	Y30 M50	Y40 M70	Y50 M100
M30	M50	M70	M100
M30 C10	M50 C30	M70 C40	M100 C50
M30 C30	M50 C50	M70 C70	M100 C100
M10 C30	M30 C50	M40 C70	M50 C100
C30	C50	C70	C100
Y10 C30	Y30 C50	Y40 C70	Y50 C100
Y30 C30	Y50 C50	Y70 C70	Y100 C100
Y30 C10	Y50 C30	Y70 C40	Y100 C50

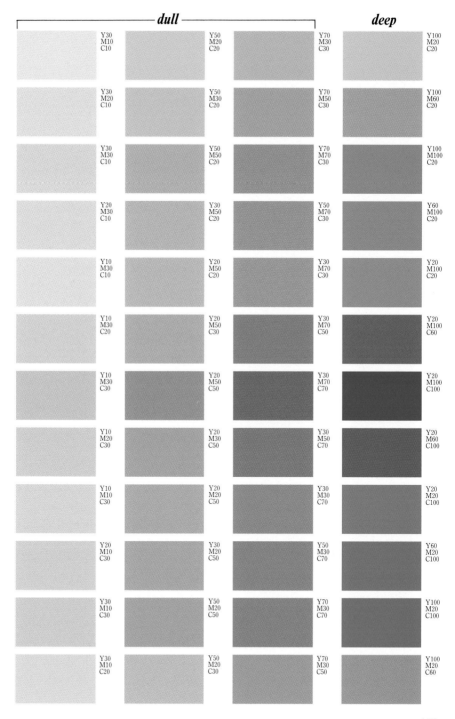

Y30 M10 C10	Y50 M20 C20	Y70 M30 C30	Y100 M20 C20
Y30 M20 C10	Y50 M30 C20	Y70 M50 C30	Y100 M60 C20
Y30 M30 C10	Y50 M50 C20	Y70 M70 C30	Y100 M100 C20
Y20 M30 C10	Y30 M50 C20	Y50 M70 C30	Y60 M100 C20
Y10 M30 C10	Y20 M50 C20	Y30 M70 C30	Y20 M100 C20
Y10 M30 C20	Y20 M50 C30	Y30 M70 C50	Y20 M100 C60
Y10 M30 C30	Y20 M50 C50	Y30 M70 C70	Y20 M100 C100
Y10 M20 C30	Y20 M30 C50	Y30 M50 C70	Y20 M60 C100
Y10 M10 C30	Y20 M20 C50	Y30 M30 C70	Y20 M20 C100
Y20 M10 C30	Y30 M20 C50	Y50 M30 C70	Y60 M20 C100
Y30 M10 C30	Y50 M20 C50	Y70 M30 C70	Y100 M20 C100
Y30 M10 C20	Y50 M20 C30	Y70 M30 C50	Y100 M20 C60

Fluorescent Colors (Fluorescent ink is used for all three colors) Printing order: C--> M--> Y

light *bright* ┌─────── *vivid* ───────┐

	Y50	Y70	Y100	M100 C100
Y50 M30	Y70 M40	Y100 M30	M70 C100	
Y50 M50	Y70 M70	Y100 M50	M50 C100	
Y30 M50	Y40 M70	Y100 M70	M30 C100	
M50	M70	Y100 M100	C100	
M50 C30	M70 C40	Y70 M100	Y30 C100	
M50 C50	M70 C70	Y50 M100	Y50 C100	
M30 C50	M40 C70	Y30 M100	Y70 C100	
C50	C70	M100	Y100 C100	
Y30 C50	Y40 C70	M100 C30	Y100 C70	
Y50 C50	Y70 C70	M100 C50	Y100 C50	
Y50 C30	Y70 C40	M100 C70	Y100 C30	

140